In Good Keeping

Virginia's Folklife Apprenticeships

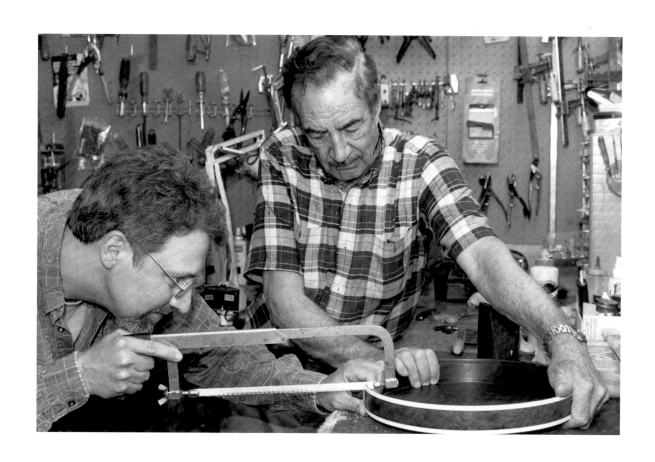

In Good Keeping

Virginia's Folklife Apprenticeships

Jon Lohman

Photographs by Morgan Miller

vfh THE VIRGINIA FOUNDATION FOR THE HUMANITIES

CHARLOTTESVILLE, VIRGINIA

The Virginia Foundation for the Humanities
145 Ednam Drive
Charlottesville, Virginia
22903

All photographs by Morgan Miller
with the exception of the image on page 200,
courtesy of Valentine Richmond History Center
Book and jacket design by Laura Chessin

Printed in Canada

ISBN 978-0-9786604-1-3
Library of Congress Control Number
200793378

In Good Keeping

CONTENTS

IN GOOD KEEPING

THE TITLE OF THIS BOOK, *In Good Keeping,* came to me atop a scenic lookout at majestic Breaks Interstate Park, the deepest gorge east of the Mississippi. Having long-labored over what to call this book, Morgan and I came to "The Breaks" for inspiration. Straddling the border of Virginia and Kentucky, The Breaks is often called "The Grand Canyon of the South" by locals who return regularly to marvel at its spectacular views. Yet it remains a great secret among America's natural wonders. Peering over the wind-worn rail of the lookout, silent but for the occasional passing of a coal train far below, one feels as though he is standing at the edge of the earth. Yet, The Breaks is not even the edge of Virginia, which still stretches another hundred miles southwest to the Cumberland Gap.

In fact, the Commonwealth of Virginia is deceptively large. It runs from the Eastern Shore, a narrow strip of land nestled between the Chesapeake Bay and the Atlantic Ocean, to the rugged Appalachian Mountains that sit as far west as Detroit, Michigan. Virginia includes the maritime regions of the Middle Peninsula and Northern Neck, and the rolling green hills of the Shenandoah Valley. It includes the coalfields of deep Southwest, and the tobacco fields of Southside. It encompasses the eroded sands, clays, and shales of the Tidewater and the fertile soils of the Piedmont. Virginia is home to several major metropolitan areas, including the capital city of Richmond, the rapidly growing conglomeration of cities along the coast known as Greater Hampton Roads, and Northern Virginia, the densely populated region across the Potomac from our nation's capital.

Each of these regions houses a dizzying number of unique cultural communities, constituted in a variety of ways—by ethnic heritage, geography, social class, occupation, or even shared passionate interests. Every community, large and small, possesses its own rich array of folklife. Whether sung or told, handcrafted or performed, a group's folklife refers to those "arts of everyday life" that signify a tangible sense of traditional knowledge, communal belonging, and shared identity. Folklife is the songs we sing, the stories we tell, the stews we cook, and the crafts we create. As the pages that follow will illustrate, our folk traditions are as much about communication as they are about aesthetics. Folklife is the way we repeatedly, over the daily course of our lives, express to each other who we are.

Virginia's folk traditions often emerge from communities that have deep ties to their region, connected to lifestyles and occupations that are closely linked to the landscape—such as farming, mining, furniture manufacturing, or fishing—industries that have long sustained life in the Commonwealth. The folk traditions of the Virginia Indian tribes date back thousands of years before Europeans arrived in Jamestown in 1607, and before Africans began arriving in 1619. Others followed, adding to the cultural landscape that we now know as Virginia. More recent arrivals developed vibrant communities throughout the Commonwealth, further expanding its dynamic cultural landscape. In each case, Virginians arrived with a complex cultural kit of folkways, and have continued to develop new richly textured traditions through interaction with others and through the unique circumstances that greeted them in the Commonwealth. And whether it is the brightly colored sawdust carpets of the recently arrived Guatemalan community in Manassas, or handmade pottery that the women of the Pamunkey Indian Tribe have been making for centuries, Virginia's folkways are not simply surviving relics of past ways, but are

constantly evolving and given new life and cultural relevance as they engage new tradition bearers.

The possibilities of human creativity are nearly endless, and Virginians have, for many generations, expressed their aesthetic impulses in a wide variety of forms. From the remarkable old-time string-band music of the Blue Ridge Mountains to the stirring *a cappella* gospel quartets of the Tidewater, from the hand-carved waterfowl decoys of the Eastern Shore to the patchwork quilts of the Shenandoah Valley, the forms of folklife in Virginia are as diverse and varied as those communities that create them. Virginia is home to some of the world's finest ballad singers, net menders, cane carvers, old-time fiddlers, ham curers, and hot rod riggers. Virginia introduced the rest of the country to the banjo, the batteau, and Brunswick Stew. And even as it faces rapid development and modernization, Virginia continues to welcome new, vibrant cultural traditions, without compromising many of its remarkably resilient folkways that have thrived here for generations.

Virginia is, in short, a folklorist's dream.

I have been fortunate to have lived that dream since 2001. In my time as state folklorist, I have traveled throughout the Commonwealth and met many folks who are astonishingly talented artists and even better people. I constantly encounter a parade of new forms of craft, work traditions, foodways, musical genres, and other expressive traditions from a seemingly endless array of cultural communities. Each new discovery seems to lead to many more. With each passing year, I find that my work never gets old, it never slows down, and it most certainly never gets boring. Every new tradition I engage seems to encompass its own unique "world"—

the bluegrass world, the quilting world, the hot rod car world, and so on. I have done my best to explore as many of these worlds as possible, putting more miles on my car than I care to count. And in all of my travels across Virginia, I have never ceased to be amazed by the hospitality, generosity, and kindness that folks have shown me over the years. Those whom I have met in travels have imparted wisdom and insights long held in good keeping, and for this I am forever grateful.

As folklorists, we are trained to ask more than we tell and to listen more than we speak. We are taught not to impose onto communities our own sets of "theories" or "constructs," but rather to meet folks where they are, hear what they have to share, see what they have to show us, and find out how we can best assist them. I have always felt that it is the commission of the Virginia Folklife Program not only to document and present Virginia's folkways, but also to look for ways to support, advocate, and help ensure the future life of these traditional artistic expressions. Thus, when I first arrived at the Folklife Program, I decided to travel the state as much as I could, to meet with traditional artists and find out what they felt were their most pressing needs. A common theme repeated in conversations, particularly with older master practitioners of traditional arts, was the fear that they might one day leave this world taking all of their traditional and experiential wisdom with them, without the chance to teach their craft to another.

The pace and structure of life in the 21st century has often made it unfeasible for our cultural folkways to be taught and learned in their traditional manner. Many of the great folk masters in Virginia were, at first, "apprentices" to the great masters from their own communities. Apprenticeships were, for many years, the primary way that trades were taught and learned in America and throughout the world. Nearly every skilled trade, from tailors to shoemakers, calligraphers to sign

painters, hairdressers to bakers to butchers, employed a kind of apprenticeship system. This was also the case in agricultural traditions, as children learned to drive draft horses, run cattle, or herd sheep at the side of a parent, older sibling, or community member. The domestic arts, as well, have long been primarily taught through apprenticeships, as family recipes and quilting stitches were learned at the pant leg or dress hem of the masters.

As work, family, and leisure have changed, the institution of the apprenticeship has largely been lost in American society. Yet apprenticeships remain the optimal, and perhaps only true way for traditional knowledge to be forwarded to future generations. Through this intimate one-on-one apprenticeship, the apprentice gains access to the subtle nuances of the particular traditional form—those elusive qualities of the craft that have invested it with such cultural resonance and traditional resilience. Apprenticeships accomplish more than the teaching and learning of a particular craft or skill. Throughout the apprenticeship, the master artist and apprentice enter into a mutually enriching cultural and personal relationship, connecting both to lessons and memories from the past, and shared visions for the future.

It became clear that for traditional folklife apprenticeships once again to thrive in Virginia, they would need institutional support. So, in 2002 I applied for and received a grant from the National Endowment for the Arts to start the Virginia Folklife Apprenticeship Program. The Virginia Folklife Apprenticeships pair experienced master artists with eager learners, in order to help ensure that a particular art form is passed on in ways that are conscious of history and faithful to tradition. The master artist is one who has achieved a high level of skill in the particular traditional art form, who is regarded as a "master" of the craft by his or

her peers, and who has learned and developed his or her skill within its traditional context. The apprentice is one who has demonstrated an interest and competency in the art form prior to the apprenticeship, and who shows a sincere commitment to learning the nuanced qualities of the tradition, and carrying the tradition into the future.

The apprenticeships are more than "workshops" or "lessons." The apprentices learn their chosen craft not in classrooms or lecture halls, but in their traditional contexts, calling upon the complete engagement of the senses, and a deep appreciation for the myriad ways in which the traditional art form operates within its larger cultural landscape.

With its tremendous size, rich textured history, and incredible cultural diversity, Virginia is home to an almost unlimited number of traditional folkways. We could continue these apprenticeships for another several decades and barely scratch the surface. Fortunately, the National Endowment for the Arts has renewed its support of the program each year. Funds from the NEA support an honorarium for the master artist and assistance to the apprentice for basic supplies and travel. Support from the NEA has also afforded us the opportunity to make several visits to each apprenticeship team to document its collaborations. For the last five years I have made these visits with my dear friend and photographer, Morgan Miller. The fruits of these visits, in images and words, are chronicled in this book.

The planning of this book has been underway since the inception of the program, and for many years our working title has been *Of Hearts and Hands: The Virginia Folklife Apprenticeships*. Evoking the idea of hearts and hands seemed perfect for many reasons, not the least of which was that they came up so often in conversations with our master artists. The heart was most commonly identified as

the place within the artists that their traditional practices most closely resided. It became clear from conversations with our master artists that their folkways were not simply "hobbies" or playful diversions, but at the very core of their sense of who they are and how they understand their place in the world. This, of course, flies in the face of many of the more misinformed and generally condescending views about folk traditions—that they are "nice," or "quaint," but not revelatory of larger cultural phenomena meriting serious scholarly inquiry—a notion that luminary folklorist Brian Sutton-Smith referred to as "the triviality barrier" for the field of folklife.

For the artists featured in this book, their traditional practices laid the foundation for their own sense of personal and communal identity. Through my work as the state folklorist, I have come to understand forms of folklife as the most powerful aesthetic responses to the most common, universal human question, "Who am I?" It is through the enactment of these traditional crafts, musical expressions, foodways, dance forms, and working traditions that our master artists, and for that matter all of us, communicate "this is who I am," or more specifically, "this is who we are," as all traditions speak to a deeper connection to a larger community.

Many of the folkways featured in our Apprenticeship Program claim deep roots in Virginia, some even predating the creation of the Commonwealth itself. Potter Mildred Moore taught her apprentice to make pots using clay gathered from the Pamunkey River just as it has been done by her Pamunkey Indian Tribe since long before the Europeans arrived. Clyde Jenkins, of Page County in the Shenandoah Valley, constructs his baskets from the same white oak forests that his ancestors used before the American Revolution. Other traditions featured in this book are equally as old, though quite new to Virginia. The ancient dance form from

Northern India, Kathak, is now practiced in South Asian communities in Arlington and throughout Northern Virginia. Sephardic Jewish songs, sung in the ancient language of Ladino, are being kept alive by Falls Church resident, and national treasure, Flory Jagoda.

When many of our master artists locate their work near the heart, they are often speaking of connections to home—and of deeply meaningful family ties. When our master artists speak about their art, talk of their parents, grandparents, and other ancestors is usually not far behind. Those who were in attendance at our first annual Folklife Apprenticeship Showcase in Charlottesville will never forget the way Marshall Cofer, an imposing presence who works with even more imposing draft horses, cried at the podium as he shared how he remembers his father every time he puts up the saddles at the end of each working day. The Paschall Brothers, masters of the *a cappella* gospel quartet singing style so closely associated with the African American community of Hampton Roads, learned everything they know from their late father, The Reverend Frank Paschall, Sr. "Every time we sing, we think of him," Reverend Frank's son Tarrence told me. "We know he's here, carrying on with us." Hundreds of miles away, atop Mount Rogers, Virginia's highest mountain top, Audrey Hash Ham carries the memory and legacy of her father as well. Albert Hash, one of the most beloved figures ever to come out of Virginia's Blue Ridge Mountains, taught fiddle making to some of the finest craftsmen in this luthier-rich region, including National Heritage Recipient Wayne Henderson. And our master flatfooter Brenda Joyce follows in the legendary nimble footsteps of her father Hoy Hayden, a humble man who virtually owned the old-time dance title in fiddling conventions throughout Southwest Virginia for decades.

Mothers, of course, are mentioned as often as fathers, as sources of traditional knowledge and continued inspiration. Corn shuck doll-maker Ganell Marshall learned her craft from her mother, as did Shenandoah Valley master quilter Mary Beery. Master canner Penny Stilwell learned all of her secrets from her mother, and she has used her apprenticeship to pass along her recipes and canning tricks to her daughter, Gail Lawrence.

Gail was not the only participant to apprentice with a family member, as many needed not to look any further than the other side of the kitchen table for the master of their chosen craft. For the talented young musician Martha Spencer to find one of the most revered old-time fiddlers she turned to her father, Thornton Spencer. Likewise Aaron Olwell would be unable to find any greater authority on Irish flute making than his father, Patrick. Ariel Hobza-Ortiz, though raised in Arlington, wanted to reconnect with her Mexican heritage and learn the folk dances of Mexico. There was no better teacher than her mother, Mexican-born master dancer Laura Ortiz. African American gospel traditions have always had a strong family presence, and both the Paschall Brothers and the Madison Hummingbirds, a Portsmouth based United House of Prayer "Shout Band," chose to include their sons and nephews among their apprentices.

Of Hearts and Hands would have made an apt title for its reference to hands as well as hearts. During our apprenticeship visits, Morgan and I had the privilege of witnessing hands shave ribbons off a block of wood to make duck hunting decoys, wield a broad ax to hew a twenty-foot log, fine-sand the neck of a mandolin or fiddle, carve the uncanny resemblance of a snake into a wooden cane, carefully usher a strand of freshly combed wool through a spinning wheel, thrust a bowling ball against metal to sink the top of a steel drum, empty twenty industrial cans of butter

beans into a smoldering 98-gallon pot of Brunswick Stew, or carefully apply a perfectly straight line of paint to the side of a hot rod automobile. We also got to watch hands delicately glide a fiddle bow, nimbly dance upon the fretboard of a mandolin, or pluck, strum, or bounce off a banjo string. We watched hands play searing licks on a guitar using finger picks, or with a single flat pick, or using no pick at all. Over time it became very clear to us that for many of our masters and apprentices, the act of working with their hands—of making something handmade in a world inundated with things often processed, plastic, or premade—seemed almost as important as the finished product itself. Mary Beery, our master quilter who comes from the Old Order Mennonite community outside of Harrisonburg, perhaps put it best as she held up her needle-scarred hands and said, "I think, when it's all said and done, pretty hands just aren't what we're going to be judged by."

Our hopes of calling the book *Of Hearts and Hands*, however, were dashed during our visit to master country ham curers Jack and Nannie Branch, of Washington County. We had just come in from Jack's ham house to the breakfast table where Nannie had laid out one of numerous epic meals that Morgan and I were treated to over the five years of apprenticeship visits, when, much to our dismay, I spotted a book of the same title on the kitchen counter. It turns out that *Hearts and Hands* is the title of a fine book by Jake Jacobson and Nancy Ellis that features some of the top instrument makers of America. The Branchs' copy was bookmarked to page 79, where none other than Jack himself was featured. It turns out that Jack, our 81-year-old master ham curer, is also revered for his construction of fiddles and standup basses. He builds these instruments in his "spare time," in his fiddle shop out behind his ham house and the "dairy,"

where he and Nannie also can everything from tomato sauce, pickles, beets, green beans, pot roast, chow chow, jams and jellies, and a few things I probably shouldn't mention.

Jack's attainment of "master" status in more than one traditional art form was not entirely unique among our apprenticeship participants. Bob Cage, a world-renowned tobacco auctioneer, is also a prolific sculptor and painter. Clyde Jenkins, master split oak basket-maker, is also a widely respected arborist. Both participants in our mandolin-making apprenticeship, master artist Gerald Anderson and apprentice Spencer Strickland, have won first prize for their instrument playing at the Galax Old Time Fiddler's Convention. In fact, many of our artists are possessors of a vast array of artistic talents, and while many of them are closely associated with a particular chosen craft, we would be mistaken to allow these artistic forms to singularly to define them.

Rocked by our kitchen counter discovery, we found that Nannie's pinto beans and corn bread did much to lift our spirits and ease our disappointment about the loss of our prospective book title. With *Hearts and Hands* no longer an option, we temporarily considered calling this book *Handing it Down*, which soon became *Handing Down*. This title held considerable promise, as it evoked a familiar term for the act of imparting and acquiring traditional knowledge, as in "I was handed down this recipe from my grandmother." Certainly, *Handing Down* effectively spoke to the inter-generational aspect of a number of our apprenticeships. Though not always the case, many of our apprenticeships aimed to transfer a particular tradition from one generation to the next. A number of our apprentices were considerably younger than their master artists, and a number of them, including Sarah Mullins (corn shuck doll making), Andrew Elder (pinstriping), Shannon Joyce (flatfoot dancing),

Martha Spencer (old-time fiddling), Seth Swingle (old-time banjo playing), Spencer Blankenship (bluegrass mandolin playing), Ariel Hobza-Ortiz (Mexican Folkloric Dance) and the next generation of Paschall Brothers (*a cappella* gospel singing) and Madison Hummingbirds (sacred trombone "Shout Band"), were all teenagers at the time of their apprenticeships. Our youngest apprentice, ten-year-old fiddle phenomenon Montana Young, studied with Buddy Pendleton, a bluegrass legend some sixty years her senior who once played with Bill Monroe.

Yet while the first five years of the Virginia Folklife Apprenticeships included its share of young apprentices, there were an equal number of apprentices who were contemporaries of their master artists. *"Handing Down"* seemed a poor descriptor of these apprentices' experiences. Also, the term "down" might mistakenly imply that the apprentices in our program entered their apprenticeships somewhat green, inexperienced, or unaccomplished at their chosen craft. This was rarely, if ever, the case. Most often the apprentices entered the program with an impressive array of skills and traditional knowledge. Our musical apprenticeships alone included numerous apprentices who have received a tremendous amount of critical acclaim and won countless music competitions. Many had even been featured on their own professional recordings prior to their apprenticeships. The Virginia Folklife Apprenticeships are not intended for beginners, but for accomplished artists who wish to gain a more in-depth understanding and mastery of a particular traditional style.

Another problem with the title *Handing Down* is its proximity to a related expression, "hand-me-down," which is used to describe the giving away of household objects—usually clothes, toys, cribs, and so forth—that have outgrown their usefulness in one social context so that they may be used in the next. While many of us deeply cherish the "hand-me-downs" we have received over our lifetimes, we also accept

them with the implicit understanding that we are likely rescuing this cherished artifact from the attic, the garage sale, or permanent rest in a landfill. We would be gravely mistaken to assume the same fate for the folkways featured in this book, or to assume that these participating masters were otherwise prepared to lay their art forms up on the shelf. The Master Artists who participated in our program were quite often in the prime of their artistic prowess, and many have found that their skills have improved, rather than diminished, over the years. In fact, in many cases our master artists credit their passionate attention to their crafts as central to keeping them young and sharp. Norman Amos, a World War II veteran and retired postal worker, can barely contain his excitement about getting to his woodshop each day in his pursuit to carve a cane for every snake indigenous to Virginia. Spencer Moore, the "guitar playing tobacco farmer" who dazzled the legendary folklorist Alan Lomax more than fifty years ago, still picks out "Old Jimmy Sutton" with a dexterity and nimbleness that would outshine players sixty years his junior.

There is another, more subtle problem with *Handing Down* that also proved the demise of another title we batted around for a while, *Passing It On*. In *Passing It On*, the traditional art is viewed as a kind of fixed object or heirloom. Viewed through this lens, the traditional activity, whether it is a particular sewing stitch, song verse, or dance step, can be simply "handed," or "passed," largely unaltered, from one user to the next. The individual artists are thus seen largely as passive, empty vessels, who "carry" or "hold" a particular tradition, until he or she hands it off to someone else. This notion of the traditional artist as a somewhat passive participant has often contributed to the traditional artist's relegation as the second-class citizens of the artworld, viewed more as "interpreters" or strict "followers" of traditional rules rather than creative, active contributors to their own art. The pages that follow will serve to

remind us that behind the traditional artist, much like those that might be called "contemporary" or "modern" is, first and foremost an artist, who attends to his or her craft and life with creativity, imagination, and passion.

Though we often speak of traditions as if they exist in the public domain, free from named authors and of indeterminate origins, they are, in fact, the result of generations of individual artists who have indelibly stamped their mark on their chosen craft, forever altering its course and affecting the work of future practitioners. Many of the traditions featured in this book can even point to specific founders. Some of these artists, such as bluegrass founding father Bill Monroe, are household names. But others, while largely unknown to the general public, have gained a kind of deity status within the tightly knit "world" of their craft, such as Kenny Howard, a.k.a. "Von Dutch," the "father of pinstriping," or Chiswell "Shilly" Langhorne, the man credited with starting the Old Belt's first tobacco auction, or the legendary Eastern Shore decoy pioneers Nathan Cobb and the Ward Brothers.

Viewing tradition through the lens of "*Handing it Down*" or "*Passing It On*" also neglects to address the different meanings that the enactment of a traditional activity assumes over historical time. Clearly Charles McRaven's act of building a hewed-log house holds an entirely different set of meanings in the 21st century than the enactment of the same act in the 18th century, even if the particular building methods have been intentionally and faithfully adhered to. I do not mean to suggest that Mac's well-researched handmade constructions, built exclusively with tools and materials created by his own hands, are in some way less "authentic" than those built in the colonial period, any more than I would challenge the "authenticity" of Joe Ayers's rendering of 19th-century banjo stylings, Clyde Jenkins's split oak baskets, or Mildred Moore's precolonial Powhatan Blackware pots. Yet, it would

clearly be misguided to suggest that adherence to centuries-old traditional methods and materials would in themselves retain the same meanings for the artist in a world inundated with "big box" home-building stores, fast food restaurants, satellite television, and Web blogs. In past generations, people built hewed-log cabins, utilizing the most-advanced technological resources at the time, out of a basic necessity for shelter. Today, Charles McRaven, like many other masters in our Apprenticeship Program, is driven by a different kind of "necessity," be it familial, regional, or even political. Sandra Bennett, master fiber artist from Tazewell County, could certainly find easier and cheaper ways to keep warm than to knit her own clothing and weave her own bed coverings from hand-spun wool. Clearly, Sandra has made a conscious choice to faithfully continue the handcraft traditions of her foremothers. The specific motivations that drive each master and apprentice are as varied as the traditional art forms represented in the apprenticeships themselves. We asked participants to weigh in on their own motivations, and their words are echoed in the pages that follow.

While folklorists have come to reject the understanding of tradition as the largely passive transmission of static cultural objects, we must largely blame ourselves for this notion's origins. The academic field of folklore primarily emerged from the study of literature, and the earliest scholars of folklore studies in America were preoccupied with the study of "oral literature." Folklorists cased the countryside in search of variations of different oral "texts," be they folktales, expressions, jokes, or ballads. The folklorist was, essentially, a "collector" of these texts, and their primary task was to record and archive and publish them. While these collections remain a critically important historical record, and while they have made a tremendous contribution to our understanding of the aesthetic lives of everyday

people, they often stand as disembodied artifacts, removed from the unique, nuanced social contexts of their production. As folklore studies broadened its scope from oral literate expressions to traditional activities that we now more generally refer to as "folklife"—including crafts and material culture, foodways, vernacular architecture, ritual, and so forth—the viewing of these practices as "texts," "objects," or "items" began to change. As the field of folklore underwent a significant theoretical upheaval late in the 1960s, folkloric "texts" came to be understood as "performances," and later "enactments," and "items" of folklore—tales, crafts, musical styles, family traditions, and so forth—came to be understood as means of cultural, aesthetic communication.

Having studied under Roger Abrahams, one of the infamous "Young Turks" who, back in the sixties, helped move the field of folklore away from notions of "text" to that of performance, enactments, and communication, I felt a certain obligation to pass on *Passing It On*, even if it did have a nice ring to it. While this decision did much to alleviate my academically induced guilt, it left us, in the waning hours before our final apprenticeship visit, woefully title-less. Searching for inspiration, Morgan and I came to The Breaks a few hours before joining the Reverend Frank Newsome for his evening service. The Reverend Newsome, a country preacher with a remarkable voice, runs the Little David Church, tucked away off a coal-truck road outside the town of Haysi, Virginia. He had spent the year teaching his apprentice the age-old art of Old Regular Baptist a cappella hymn singing, one of several gospel-related apprenticeships over the last five years. Anticipating our visit to Little David was somewhat bittersweet for us, as it meant the culmination of our five-year journey to document the Virginia Folklife Apprenticeships.

Looking out over the rail of the scenic lookout, I couldn't help but reflect on the wonderful explorations that we had made over the past five years, and how much gratitude I feel towards our participants, who let us enter their homes, marvel at their talents, document their work, eat at their tables, and briefly experience their worlds. I looked out at the magnificent view of the gorge below, untouched by development, and thought of some of the changes I've witnessed in Virginia in just these five short years. So many of the places we have visited, and have featured in this book, have undergone rapid development over the past few years, and more is undoubtedly on the horizon. Looking out at the silent cliffs of Breaks, I couldn't help but feel grateful. "Thank goodness it won't happen here," I thought, "I'm glad this is in good keeping." Then it hit me. "I got it!" I shouted, *"In Good Keeping*! That's our title!"

In Good Keeping speaks to the very heart of the Apprenticeship Program, and the work of the Virginia Folklife Program more broadly. It is important to remember that the engagement of any traditional activity, be it the singing of a ballad, the cooking of a stew, or the weaving of a basket, is the act of a unique individual or group of individuals in a particular cultural context and historical time. Every time we draw on traditional knowledge to create or perform, we are, in a sense, temporary "keepers" of a cultural practice whose form is the result of the cumulative contributions of all who have enacted it before us. Our cultural enactments are also invariably affected by our notions of our "audience"—both known and imagined, and constantly shifting and changing—be they family, community, consumers, scholars, or peers. While the traditional forms of aesthetic communication that we have come to call "folklife" have long preceded us and will likely long outlive us, they only truly exist inasmuch as they are enacted in the present. While we briefly and delicately hold this particular traditional act in our hands, we can't

help but inject a bit of our own personal, creative flavor—our own preferences and predispositions, our own sense of humor and humility, our own shape and style.

What I like best about *In Good Keeping* is the way it also speaks to the wonderful and enduring paradox at the heart of the apprenticeship concept. By taking the time to impart one's traditional knowledge to another—by sharing treasured secrets, recipes, and tricks of the trade—we are in fact doing the single most important act in keeping these traditions for ourselves and our communities. The best way to keep something for ourselves might just be to share it with someone else.

The world of the master craftsman, musician, dancer, or cook can often be highly secretive, competitive, and guarded. So, we do not regard our artists' willingness to take on apprentices lightly. Rather, we feel a great debt of gratitude to our master artists for the seeds they have so generously sewn in these apprenticeships—some of which have already borne fruit, and others that will likely grow deep roots and expansive branches that we may not live to see or be able immediately to envision.

We also applaud our apprentices for their interest, wisdom, dedication, and passion. All have shown great commitment and have tended to these traditions with a steady hand, a listening ear, an open mind, and a caring heart. We are grateful that they have allowed us to witness the beginnings of what for many of them will be a lifelong journey, and we can hardly wait to see where they, and their chosen traditional craft, lead one another. As the state folklorist, I simply can't express how reassuring it is to know that Virginia's cherished traditional folkways are, in their capable hands, held in good keeping.

Jon Lohman
Charlottesville, Virginia

For the Tradition Keepers

Old-Time Fiddle

Master Artist
Thornton Spencer

Apprentice
Martha Spencer

THE EARLY SONG COLLECTING JOURNEYS of folklorists informed the rest of America about the remarkable breadth of fiddle tunes in the mountains of Southwest Virginia, many of which closely resembled songs collected in the British Isles generations earlier. Still the music of choice for country dances and the competitive focus of a vibrant network of fiddler's conventions, old time fiddling continues to thrive in Southwest Virginia. Grayson County master fiddler Thornton Spencer learned to play in the 1940s from his brother-in-law, the revered fiddle maker and player Albert Hash. Thornton and his wife, banjoist and music instructor Emily Spencer, later joined Albert to form the legendary Whitetop Mountain Band, still one of the most-beloved old time bands in the region. Thornton and Emily's daughter Martha Spencer has been immersed in old-time music her entire life. Already a gifted multi-instrumentalist, Martha has used her apprenticeship opportunity to focus on the nuances of the fiddle.

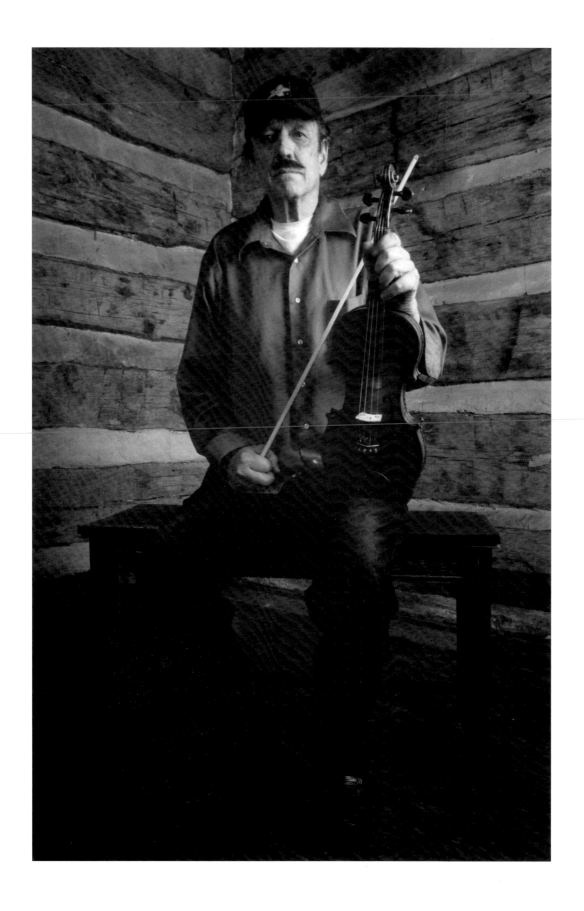

Home is where the fiddle rings
Home is where my momma sings
Home is where the mountains are high
Home is where my heart is.

from the song "Home is Where My Heart Is,"
written by Martha Spencer
during her apprenticeship with her father.

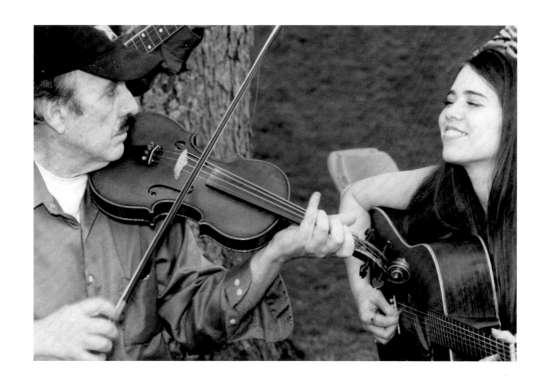

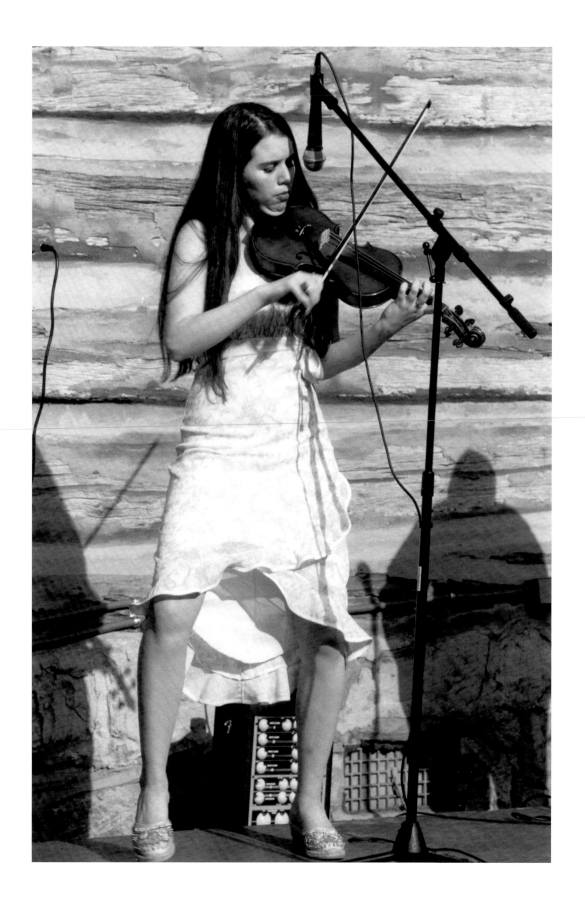

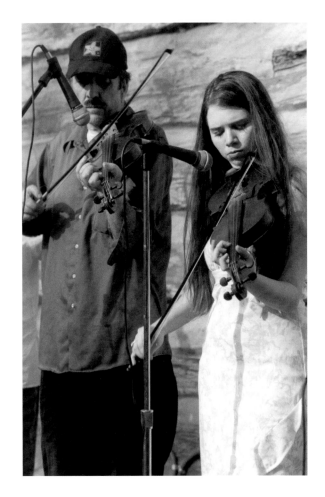

What got me into playing the fiddle was Albert. I was just a kid, and I used to pick the guitar with him some in his fiddle shop. One day, I was admiring one of his fiddles he had hanging on the wall and he said to me, "Thornton, I believe you can learn." So he showed me how to play two tunes—the Chicken Reel *and* Rag Time Annie.

He was going to visit his brothers out in Appomattox for a couple days, and he said I could have that fiddle if I could play those tunes by the time he got back. Well, I suppose I sawed on them some, enough for him to give it to me, and that's where it started. Martha started out on the guitar, too, but she's been improving on the fiddle every day. I'm just real proud to have someone to carry on the tradition of Whitetop fiddling to the next generation.

Thornton Spencer
Master Old Time Fiddler

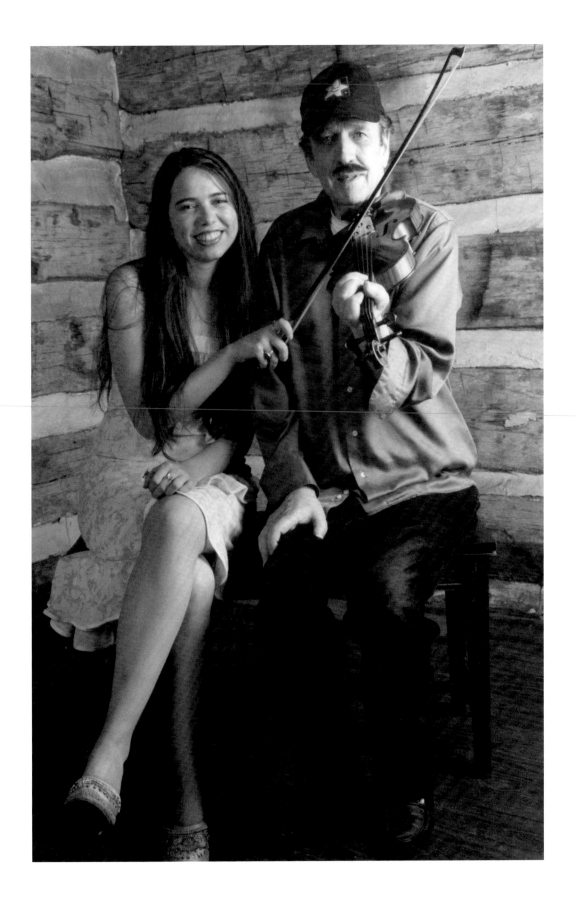

Shenandoah Valley Quilting

Master Artist
Mary Beery

Apprentices
Mollie Beery
& Joan Knight

THE SHENANDOAH VALLEY HAS LONG BEEN HOME to some of the country's finest quilters. Among those who have contributed to the quilting tradition of the region are the Mennonites, who established their first community in the Shenandoah Valley about 1727, and were well settled in the region by the 1780s. Today the Mennonites remain a thriving close-knit culture in the Valley, maintaining traditional customs associated with work, travel, dress, and worship. Mary Beery has for many years been regarded both within and outside the Mennonite community as one of the most gifted quilters of her generation. Quilters generally prefer to work in small groups or "quilting bees," so Mary took on two apprentices: her niece Mollie Beery and Virginia Quilt Museum Director, Joan Knight.

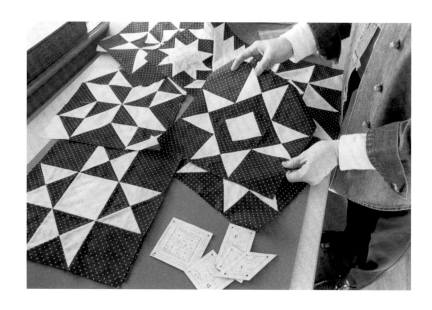

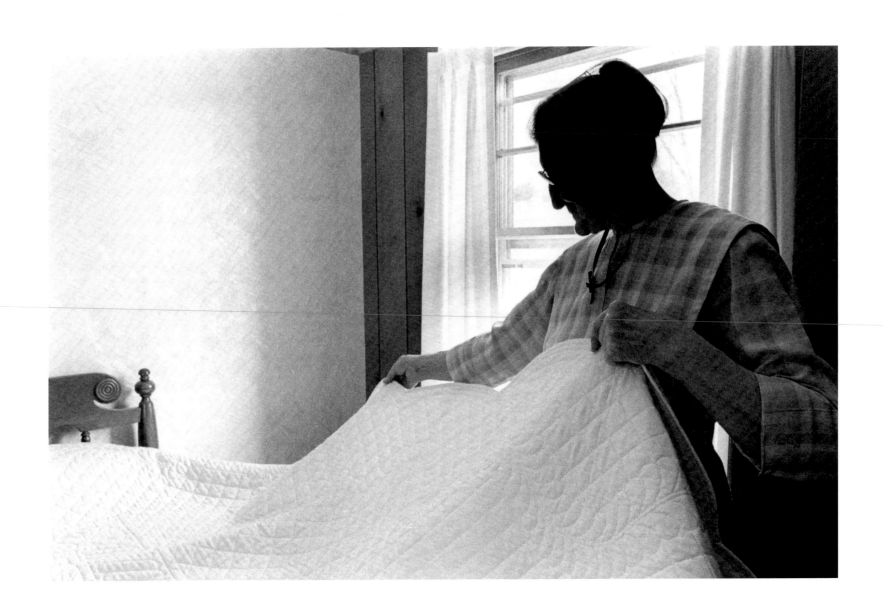

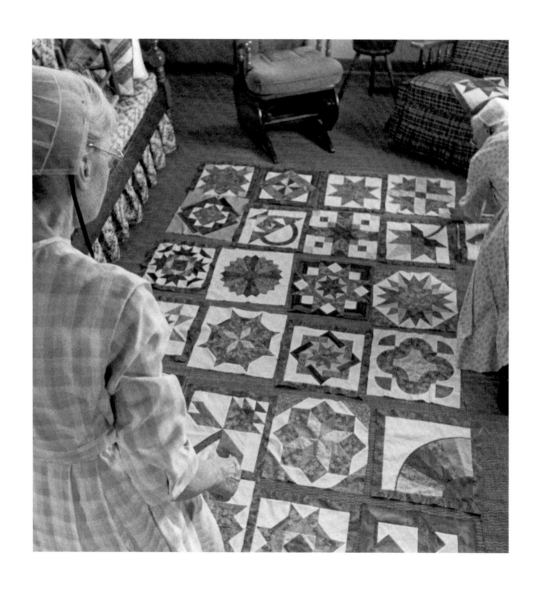

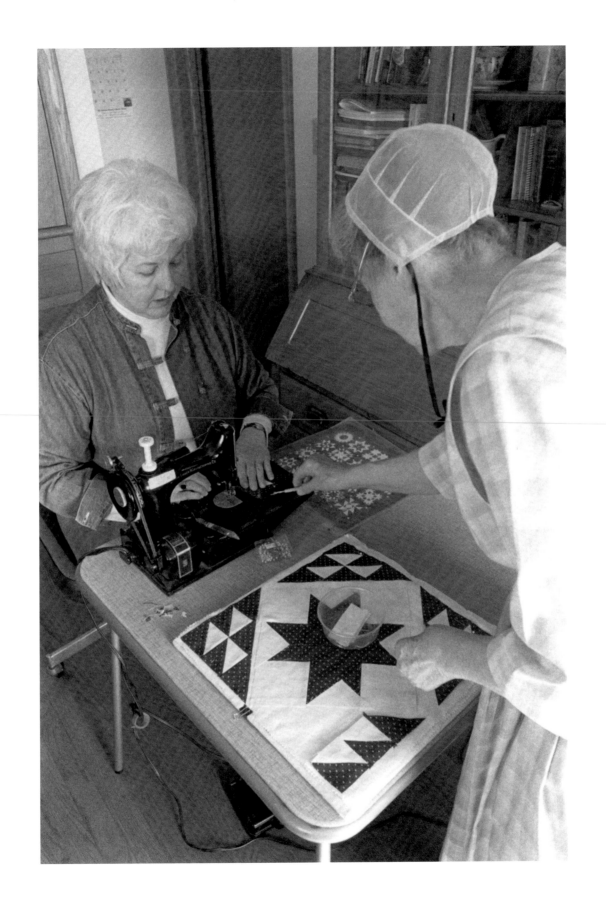

*I was taking a quilting class at a local fabric store and the teacher
couldn't make it. So they asked Aunt Mary to come in and teach.
When I showed her my quilt block she was surprised at how bad it was.
Before I started quilting with her, she said, "You WILL learn this,"
and I said, "Well, I don't know if you know me that well, Aunt Mary!"
She still said, "Yes, you will!"*

Mollie Beery
Apprentice, Shenandoah Valley Quilting

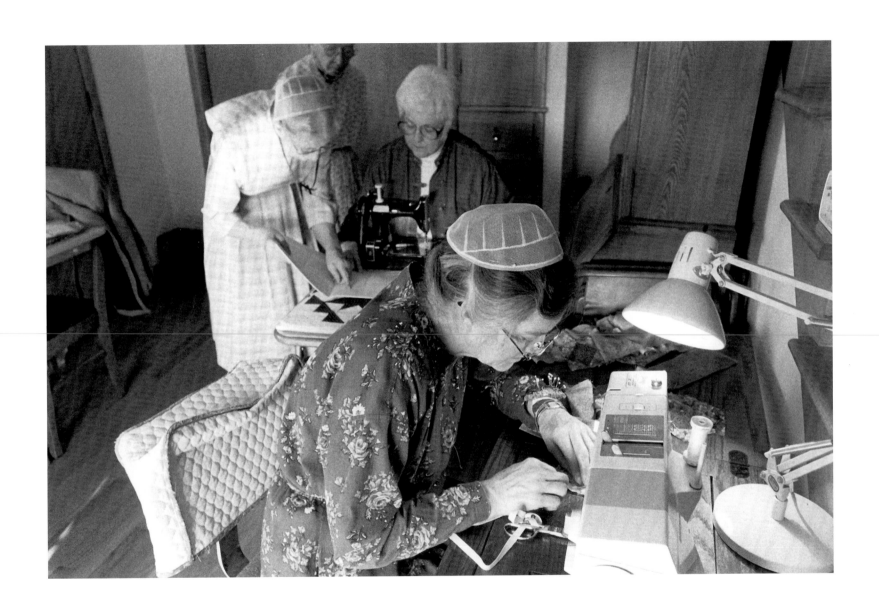

Draft Horse Training

Master Artist
C. Marshall Cofer

Apprentice
Rebecca Austin

LONG BEFORE THE MAJORITY OF AGRICULTURAL LIFE became mechanized, farmers relied on draft horses and other animals to carry out most of their daily tasks and to serve as the central means to transport their goods to the marketplace. Draft horses are the larger, more muscular breeds of horses, including Clydesdales, Belgians, and Shires. While the traditional skill of handling draft horses is largely lost on today's generation, it remains alive in the work of draft horse teamster Marshall Cofer, who learned this craft as a child growing up on a farm in Bedford County. Marshall's family didn't own a car until he was thirteen, so they relied on horses as their sole means of transportation. As a teenager, Marshall delivered the *Grit*, a weekly newspaper, by horseback, covering an 18-mile route. Marshall now breeds and drives Percheron draft horses, and he has demonstrated his skills to many young people, most recently at the farm museum at the Blue Ridge Institute in Ferrum, where he met his eager young apprentice, Rebecca Austin. Rebecca used her apprenticeship with Marshall not only to continue this tradition herself, but also to assist him in teaching it to others.

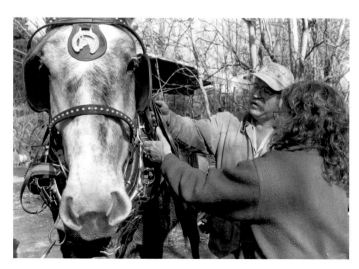

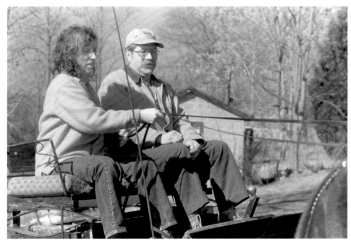

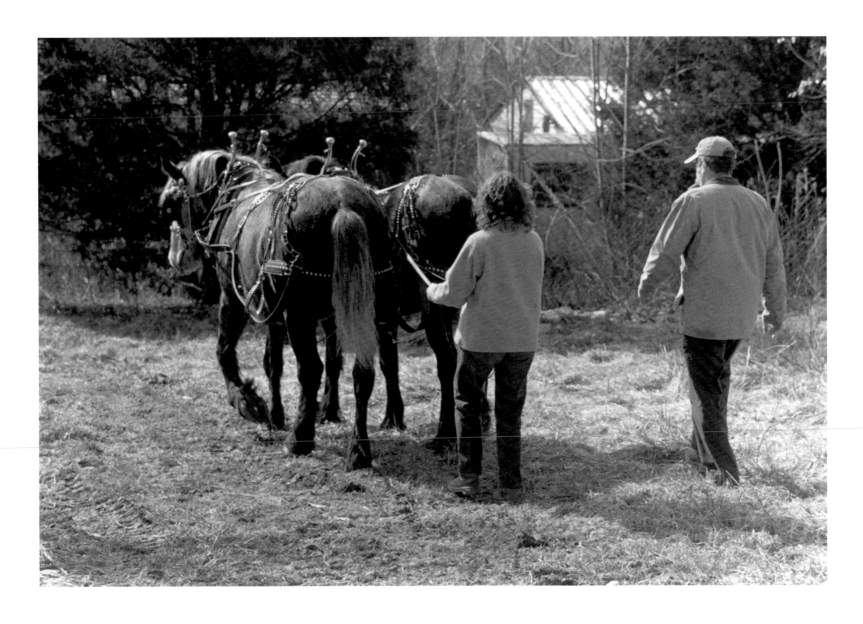

Most of this stuff, it's not just about gaining a skill.
I mean, I can say that with the horses especially, it's
not just like sitting down and learning how to make
something. It's a living thing. And I can't imagine that
if I keep on with this, that I'll ever stop learning about
it. It's a way of life, really, and it'll be forever.

Rebecca Austin
Apprentice, Draft Horse Training

43

Hot Rod Rigging

Master Artist
John Rinehart

Apprentice
Don Fitzgerald

EVER SINCE THE AUTOMOBILE has been mass produced by the assembly lines of Detroit, it has been revised, altered, elaborated, and reconstructed in small garages and car shops throughout America. The historic practice of creating visually dynamic "hot rods" is particularly rich in Southwest Virginia, where many automobiles were "souped-up" as part of the bootlegging tradition, and where car clubs have, and continue to thrive as an important social network. John Rinehart's family moved to Roanoke in 1953, when he was ten years old. Several years later, John made his first run down the Roanoke Drag Strip, where he won the regional soap box derby, and cemented his lifelong passion for the automobile. John went on to learn the hot rod rigging tradition in the garages of many of the city's finest masters, and his apprenticing of accomplished car customizer Don Fitzgerald represents a critical link in this traditional chain.

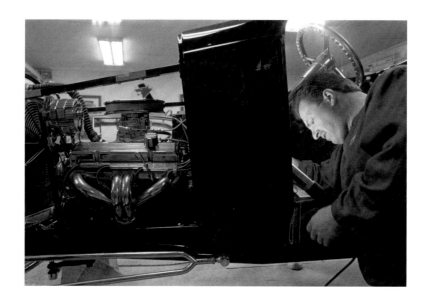

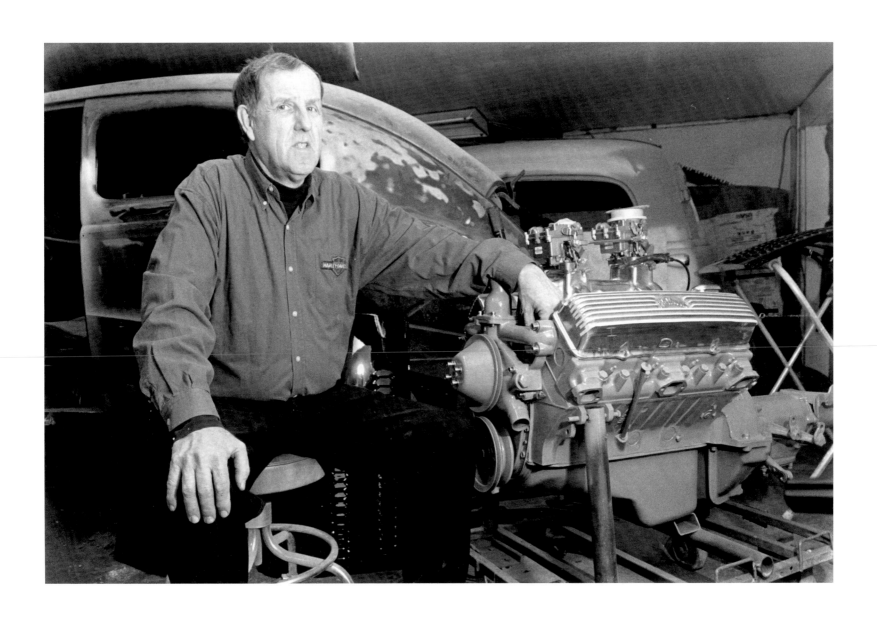

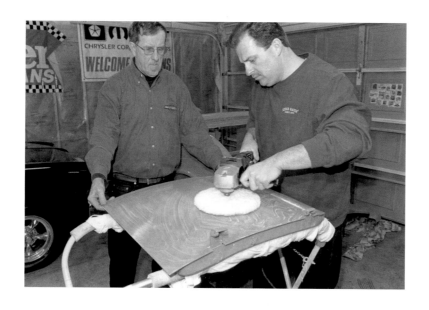

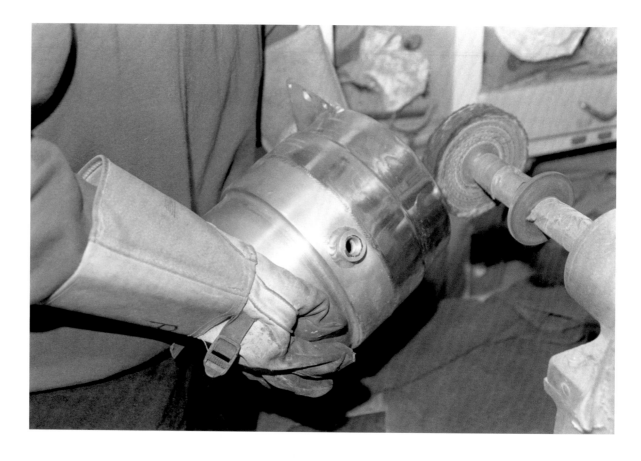

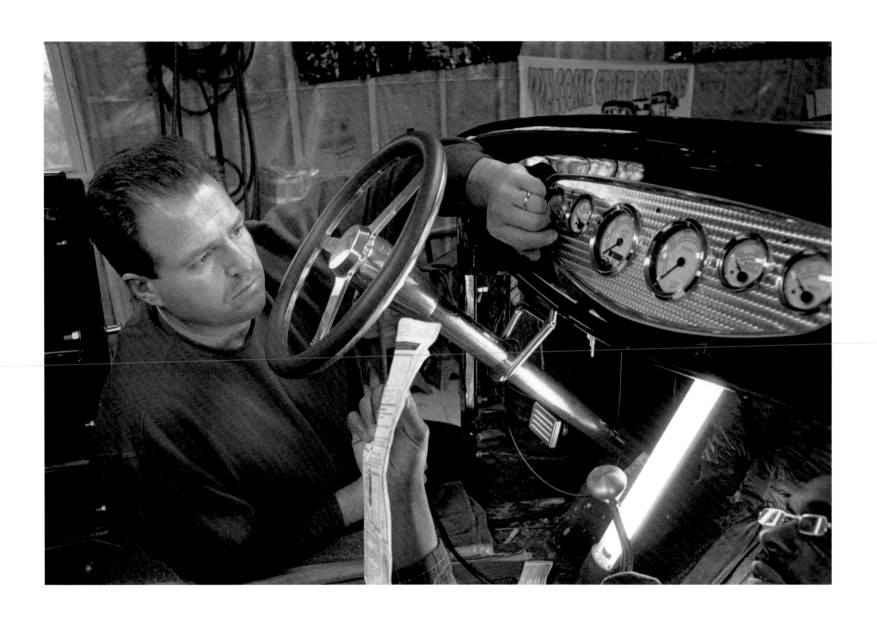

When you're driving one of these cars, it seems like everyone's looking at you. It draws a lot of attention. Is this something you enjoy?

Oh, definitely. When you're coming up the road, you get the "thumbs up" all day long, and you can tell you're bringing back memories.
Like my neighbor, he's an older gentleman, probably in his late 70s or early 80s. And when he sees me take this out of the garage, he just stops and stares. And I can tell he's thinking back to when he used to drive these cars. Maybe it takes him back to sitting in the back seat, riding with his parents, things like that. That's what it's really about for me, more than the notoriety part of it.

But it is fun. Don't get me wrong.

Don Fitzgerald
Apprentice, Hot Rod Rigging

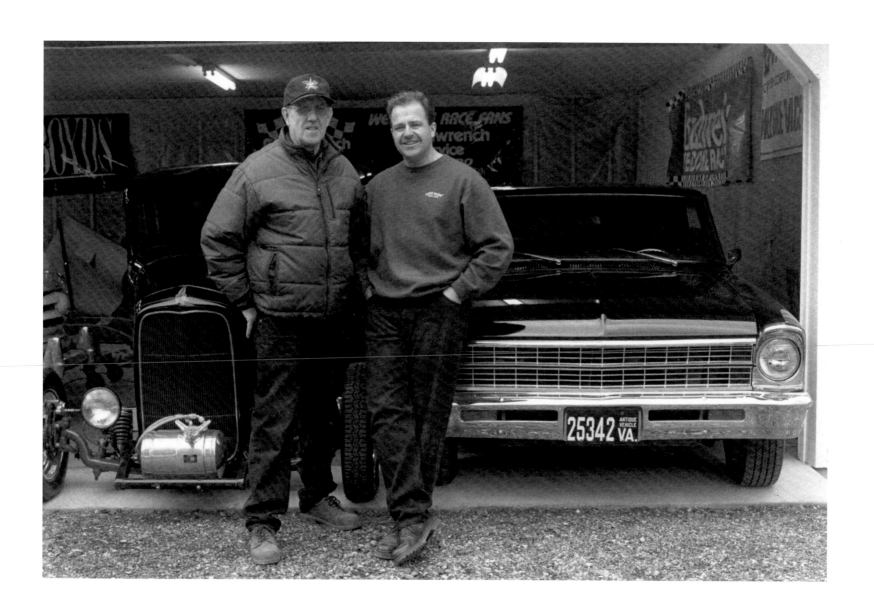

Piedmont Blues Guitar

Master Artist

John Cephas

Apprentice

Marc Pessar

WHILE PERHAPS NOT AS WELL KNOWN as the Mississippi Delta style, Virginia has long been home to its own style of blues—the "Piedmont Blues." And, just as it is in the Delta, the guitar is king of the Piedmont Blues. By far, the most distinctive feature of the Piedmont guitar style is its finger-picking method, in which the thumb lays down a rhythmic bass-line against which one or two fingers pluck out the melody of the tune. Using this technique, the Piedmont guitarist makes a single instrument sound like several, setting up a complex dialogue of bass and treble parts. John Cephas of Bowling Green, Virginia, is without question the world's foremost Piedmont bluesman. John learned to play guitar from family members and neighbors in Caroline County at the many "county breakdowns" and house parties that have long been a staple of African American social life in the region. His collaborations with harmonica master Phil Wiggins have been delighting audiences throughout the world for decades, and in 1989 John was honored with the National Heritage Fellowship. John enjoys teaching at guitar camps throughout the country, and it was at one of these music camps that he met his apprentice, Marc Pessar, who he considers one of his most promising students.

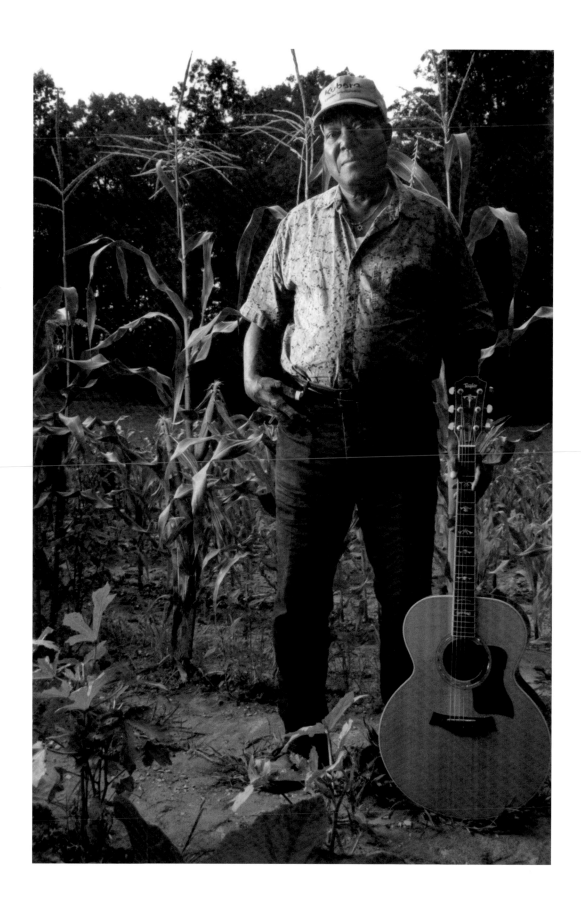

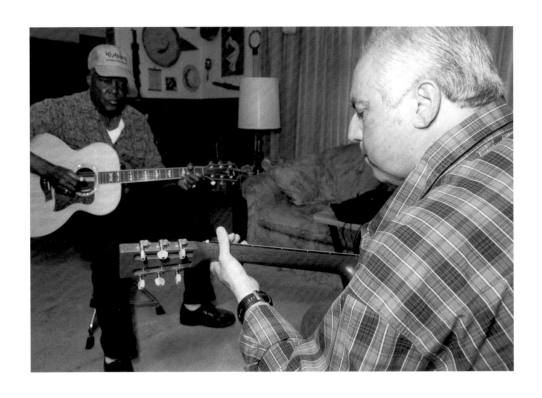

Wherever there is a listening ear, that's where I want to play.
I don't have no preference. If people are there, here I am,
so go send me. This is my talent, to play and teach others this
technique. This is where my crown of glory comes in. I've learned it,
I can play it, people hear it, and I can teach it. These blues—
this Piedmont style—touched Marc the way it has touched so many.
It came from the black community, but has come to affect every
ethnic group in the world.

John Cephas
Virginia's Blues Man

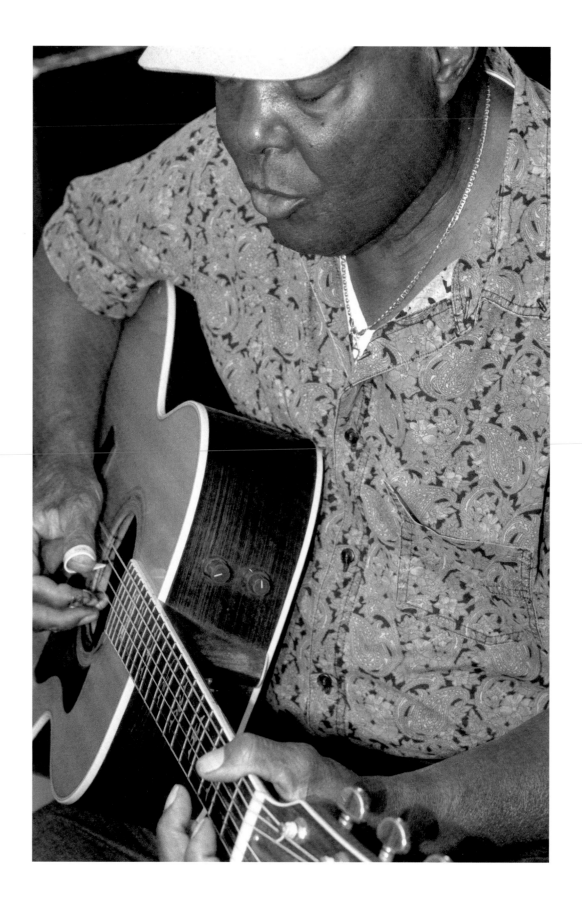

Country Ham Curing

Master Artists
Jack & Nannie Branch

Apprentice
John Maeder

THERE IS PROBABLY NO OTHER TRADITIONAL FOOD more associated with Southwest Virginia than country ham. Unlike the more commonly known wet-cured ham, which is soaked in brine or injected with a salt solution, country ham is dry-cured and aged over a much longer period. The curing of fresh pork hams takes nine months, usually beginning in November. The hams are salted, sugared, and peppered at different intervals throughout the process. Jack Branch first learned this process when he was eight years old, watching his father and grandfather cure hams from their family-owned hogs. Jack has honed his ham-curing techniques over the years, with the help of his wife Nannie Branch.

Local music enthusiast John Maeder first sought Jack out because of his reputation as a fine fiddle maker. John returned to the Branches many times to spend time in Jack's fiddle shop, as well as at their dinner table, where he was often treated to Nannie's country cooking, and their home-cured hams. John's appetite led him to spend more time in Jack's ham house than his fiddle shop, eventually resulting in a ham-curing apprenticeship.

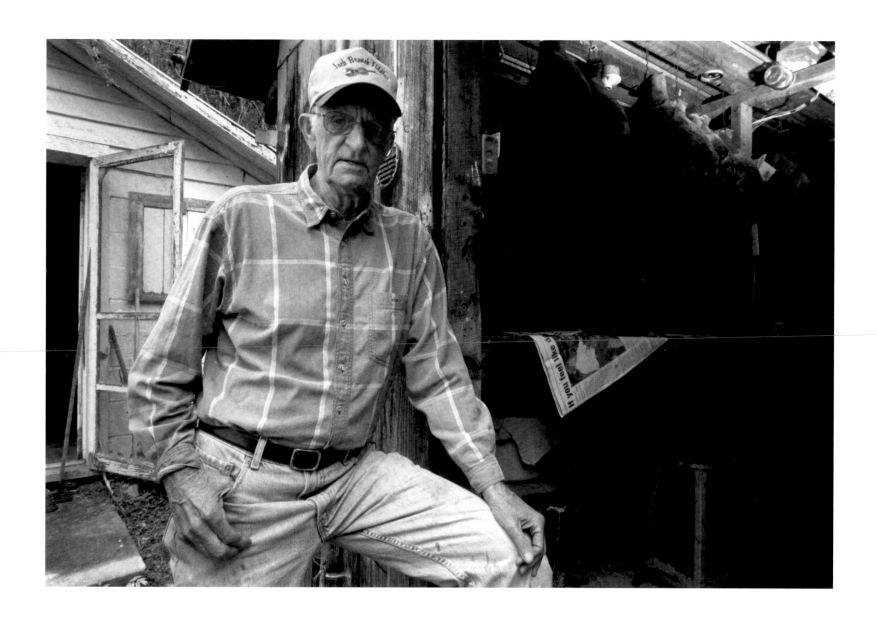

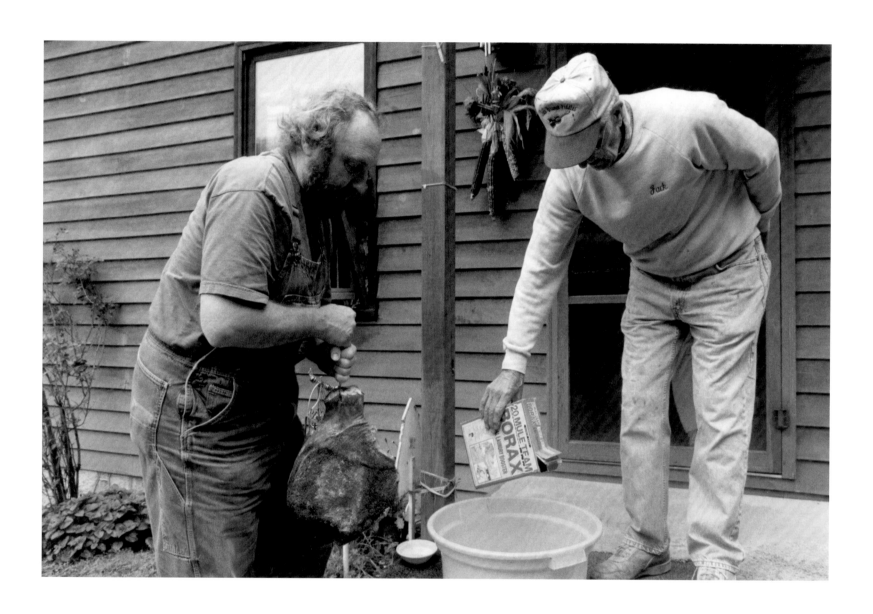

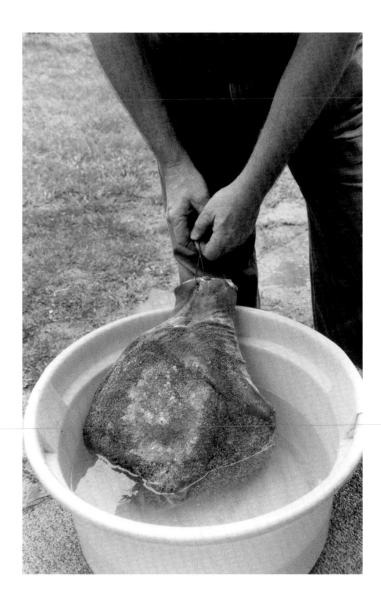

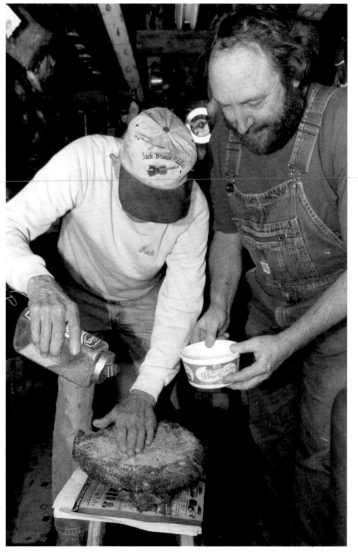

This guy once came to me and asked if I could build a ham house, you know, to start selling them. I said no way. You see, in the end you can't make more than two or three dollars a ham, so it's really not worth selling them. But we just love to do it—curing hams, canning, everything. We canned all summer. We got ourselves a dairy full of food, and I reckon we're ready for the winter. That's how me and Nannie's always done it ... the old way.

Jack Branch
Master Ham Curer and Jack-of-All-Trades

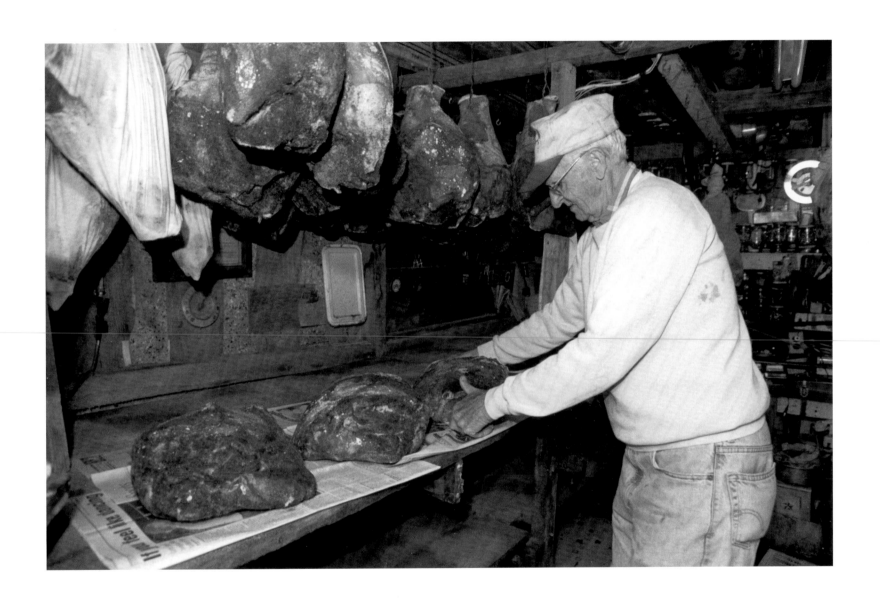

Mexican Folkloric Dance

Master Artist
Laura Ortiz

Apprentice
Ariel Hobza-Ortiz

MEXICANS COMPRISE ONE OF THE FASTEST-GROWING immigrant populations in Virginia. This emerging cultural community has already contributed a plethora of traditional folkways to the diverse tapestry of Virginia Folklife, including a dynamic folk dance tradition. Laura Ortiz learned different styles of this traditional art in her native home of Mexico City, dancing Mexican Folkloric Dances and Spanish Flamenco as a young child. In the early seventies, Laura moved to Los Angeles, where she soon joined the well-respected professional company Ballet Folklorico Mexicapan. After moving to Northern Virginia, Laura founded Los Quetzales Mexican Dance Ensemble in 1997 to present and share this dance with members of her local community. She has been working with her young apprentice, daughter Ariel Hobza-Ortiz, for more than five years.

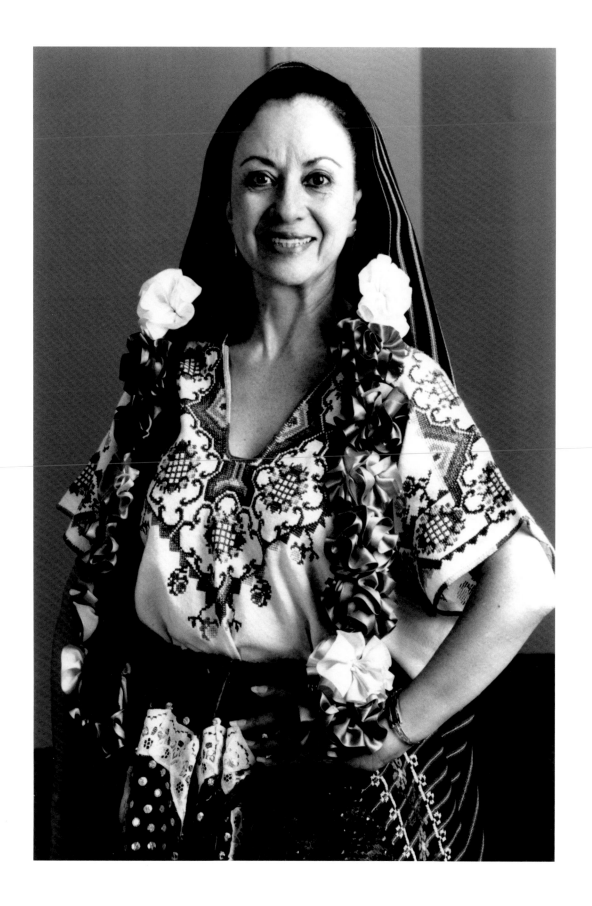

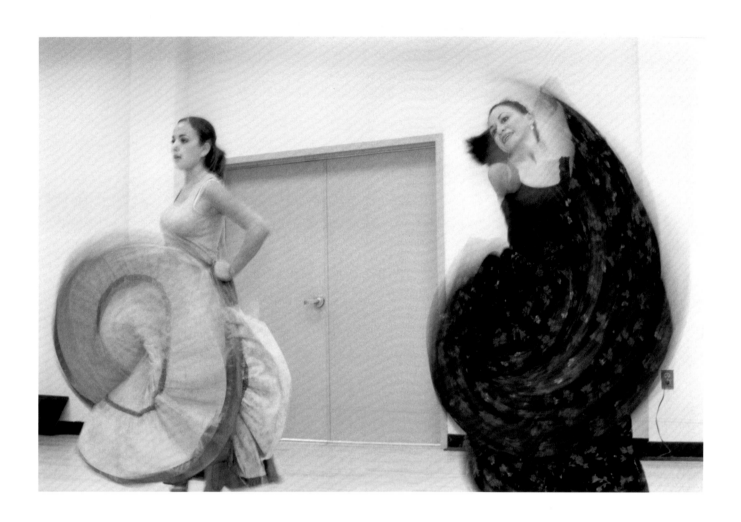

She gives a lot of lessons to a lot of different people, but for me I guess it's extra special because she's my mom. It's not that she treats me any different than the other girls, it's just that it seems to come easier for me. I mean, dancing is in my blood.

Ariel Hobza-Ortiz
Apprentice, Mexican Folkloric Dance

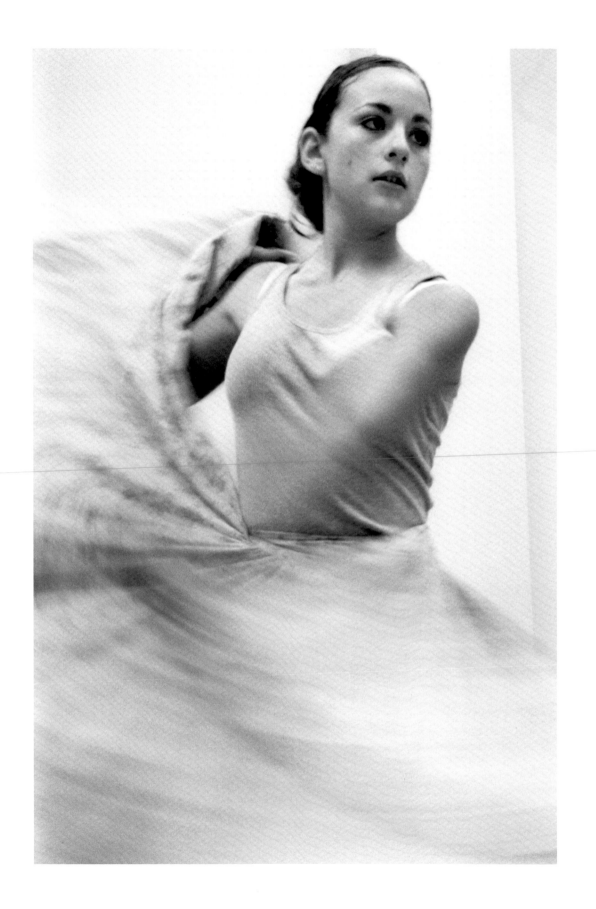

Classic Banjo

Master Artist
Joe Ayers

Apprentice
Patrick Hester

JOE AYERS HAS LITERALLY REWRITTEN THE HISTORY BOOKS regarding the development of the banjo in America. Joe, who lives in an 18th-century house in the gently rolling hills of rural Fluvanna County, is a banjoist revered for his deeply soulful playing style and his tireless dedication to historical accuracy. Joe's rediscovery of a series of mid-19th-century banjo instructional books shook up the banjo world and has provided the most accurate account of the true sound of early banjo, particularly the down-stroke "Classic Banjo Style" of the Virginia Tidewater. This style, deeply rooted in Africa, preceded the more familiar "clawhammer" style of the Appalachian region. Joe has introduced this classic style to his young apprentice, Patrick Hester. Through his apprenticeship with Joe, Patrick, a dedicated Civil War re-enactor, has helped to pass along this nearly forgotten early banjo method.

I was at a reenactment this past weekend and the band didn't show up.
I really didn't feel ready to play these songs for other people yet, especially
there 'cause those folks don't miss a thing. I mean, if it doesn't sound just
like the sixties—and I mean the 1860s—they're going to let you know.
We have Joe to thank for that. Before him, they played all kinds of music
at these things. I don't think anyone knew what the music from this period
really sounded like. But now they know. So, I strapped on the banjo and
gave it a try. And Joe was kind of there on my shoulder. I could hear him
saying "Relax Patrick, relax. Remember your positioning."

So for me, apprenticing with Joe isn't just a history lesson, but a
very active part of my life.

Patrick Hester
Apprentice, Classic Banjo

Boat Building

Master Artist
George Butler

Apprentice
Warner Rice

THE STORY OF REEDVILLE, VIRGINIA, is linked to the commercial fishing industry that developed late in the 19th century. From this tiny fishermen's town located between the Potomac and Rappahannock Rivers on the Northern Neck, watermen have cast their pots and pound nets to catch fish, crabs, and oysters for hundreds of years. Reedville is still one of the most active fishing ports in America, and home to a thriving menhaden commercial fishing industry. Along with its fishing heritage, Reedville boasts a proud history of boat building, and there is no resident of Reedville more deeply steeped in this tradition than third generation boat-builder George Butler. George has spent his entire life around the Reedville Marine Railway, the boatyard established by his grandfather. Today, George runs the boatyard. George apprenticed Warner Rice, whose grandfather, Herbert Rice, built the last menhaden fishing vessel ever constructed in Reedville.

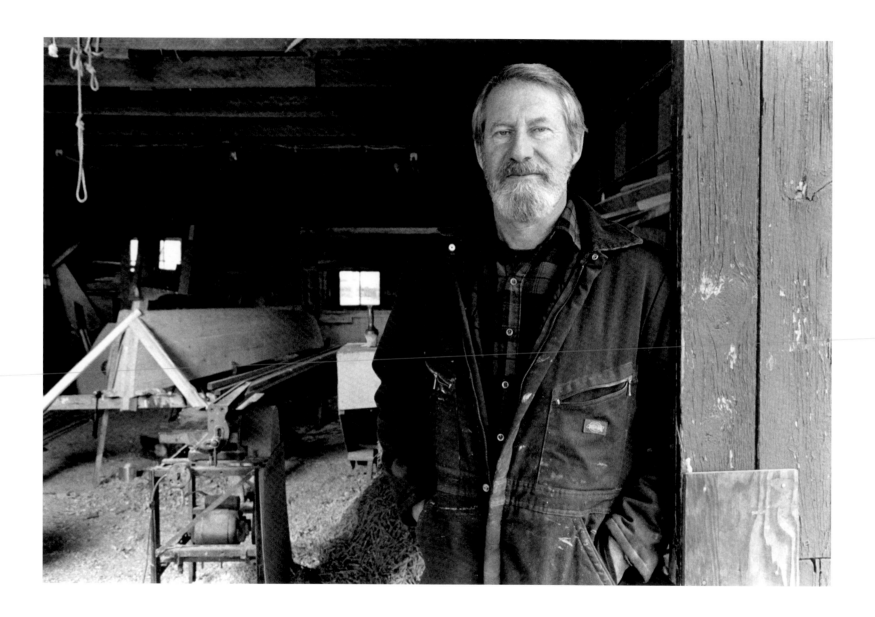

To be honest, I was pretty reluctant about taking on an
apprentice. I really prefer to work alone, always have.
I guess my main concern was that we wouldn't work well
together. But with Warner, that just wasn't a problem.
I knew him a little bit before but I got to know him much
better through the apprenticeship. Building boats tends
to do that.

George Butler
Master Boat Builder

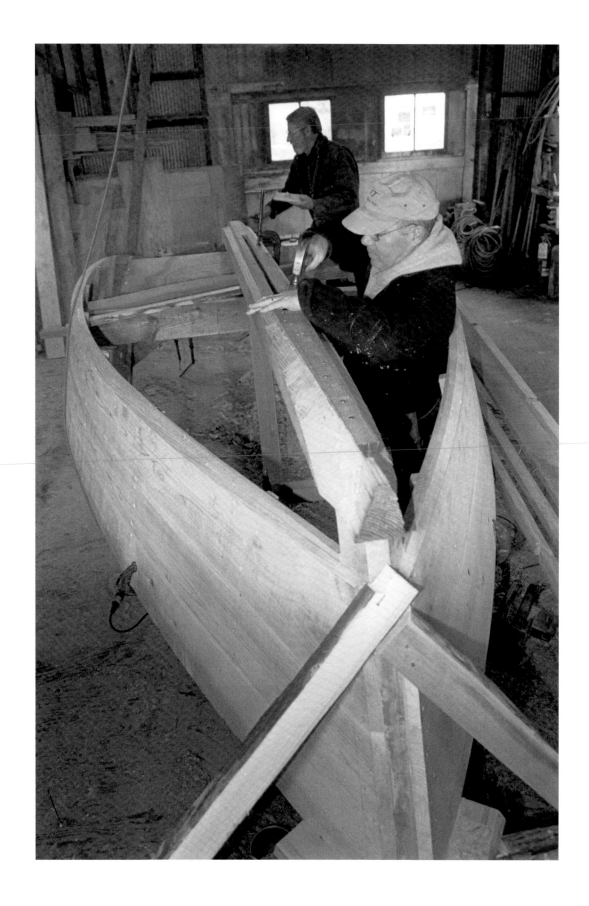

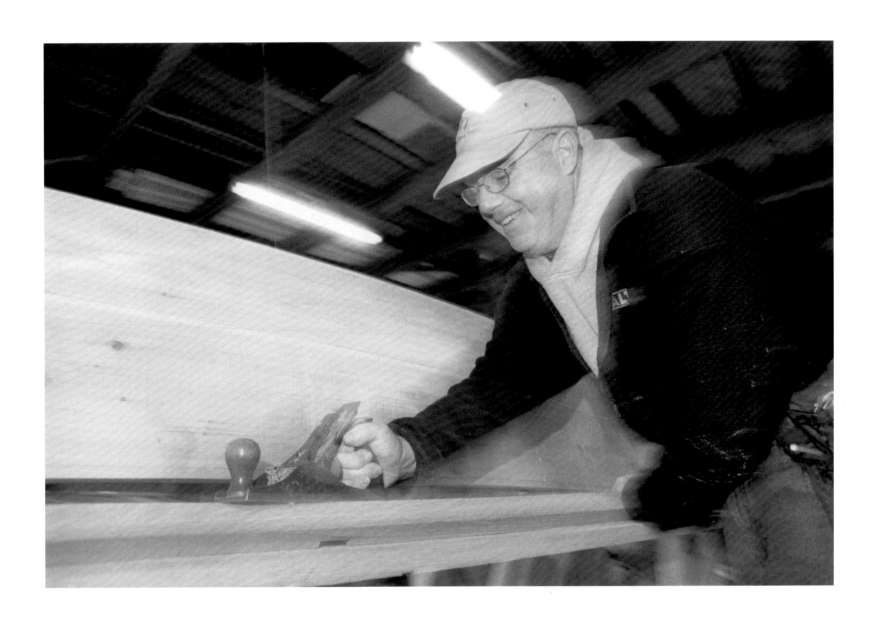

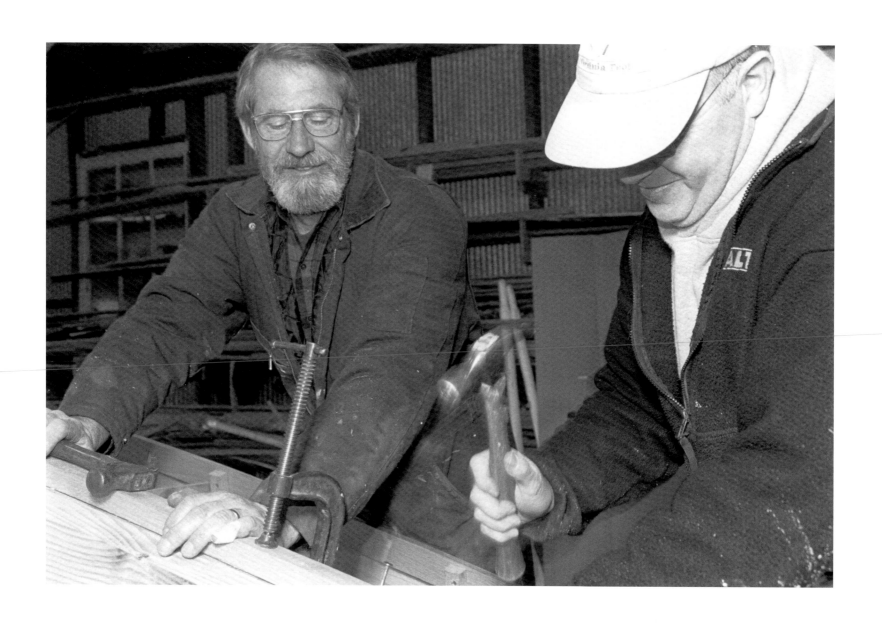

Canning

Master Artist
Penny Stilwell

Apprentice
D. Gail Lawrence

BORN OUT OF NECESSITY LONG BEFORE REFRIGERATION, "canning"—the process of preserving traditional jams, jellies, relishes, and pickles by hand—has been elevated by master canners such as Penny Stilwell into an art form. Canning has been nothing short of a way of life for Penny since she was six years old. Penny cans "everything," from beets to okra, from apple butter to roasted tomatoes. Because most of her recipes exist only in her head, Penny decided to teach her daughter and apprentice D. Gail Lawrence many of her unrecorded recipes, and share with her some of her most-cherished canning secrets.

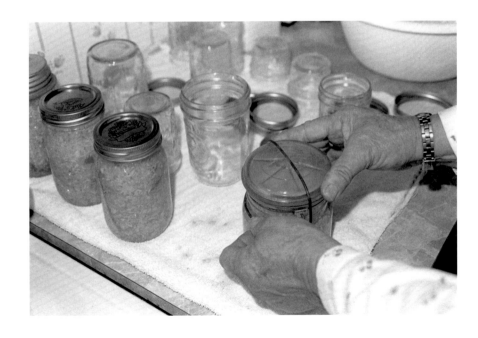

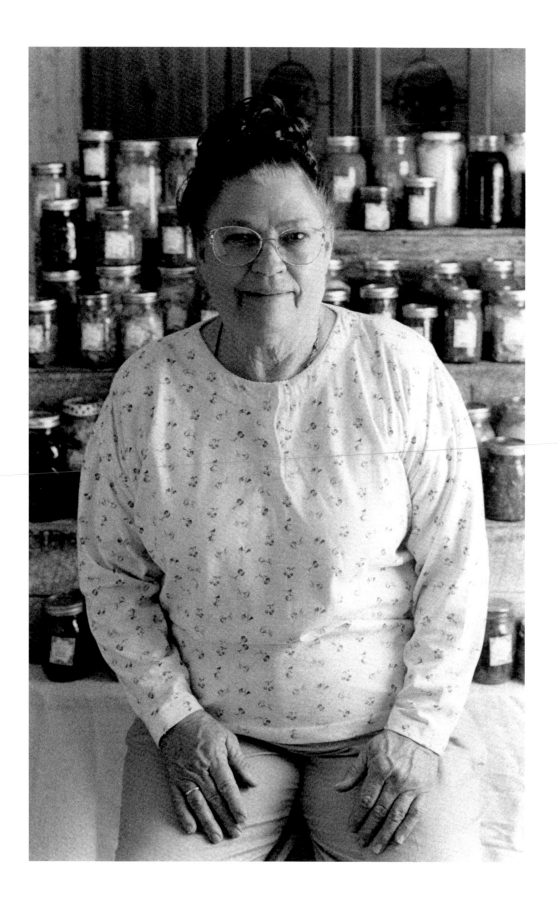

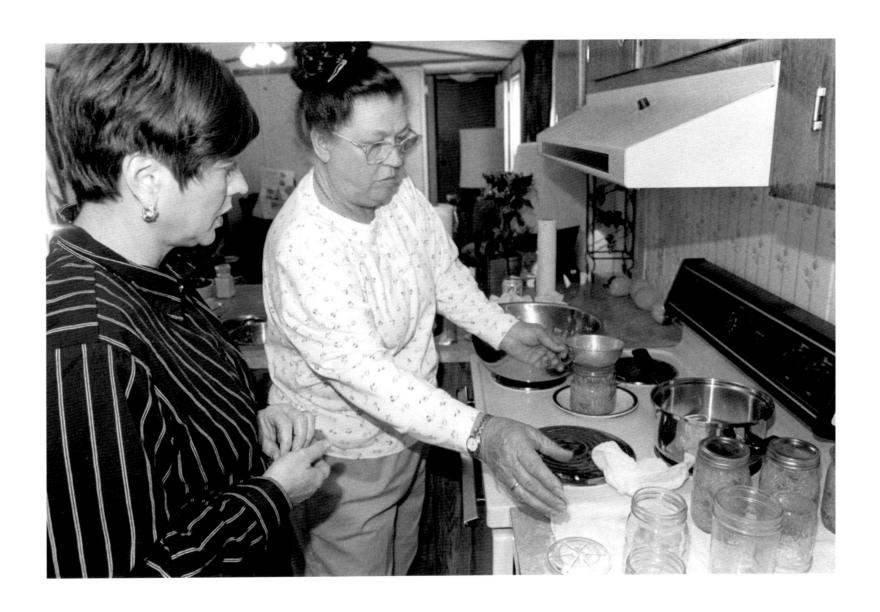

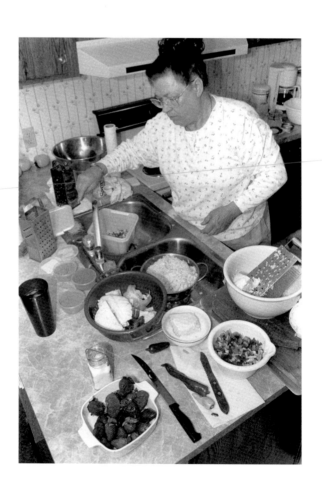

*To be recognized as a "Master Artist" for this was
something I would have never dreamed. I mean,
canning was always just something you did. It was
just how we survived. My mother, she canned
everything. And she never wrote any of her recipes down.
Actually, I don't remember her ever really teaching me
about this. I guess I just learned by watching. It was
just always around.*

Penny Stilwell
Master Canner

Fiddle Making

Master Artist
Audrey Hash Ham

Apprentice
Carl Powers

THERE IS PERHAPS NO SOUND MORE ASSOCIATED with the Blue Ridge Mountains than that of a bow gliding across the strings of a fiddle. While much attention has been focused on the masterful work of the great players of this time-honored instrument, it is equally important to pay honor to the great fiddle makers of the region. Audrey Hash Ham is the daughter of the late Albert Hash, the much beloved fiddle-maker who taught so many of the area's finest luthiers. Fiddle making is in Audrey's blood—in fact, when she was born, Albert couldn't afford her medical bills, and famously traded the doctor a home-made fiddle for her delivery. Audrey began learning to make instruments at her father's side when she was seven years old. Today, Audrey carries on her father's legacy by attending to her craft with a generous heart and joyous spirit. While she has trained many young students in the art of fiddle making, she considers apprentice Carl Powers to have been her most dedicated student.

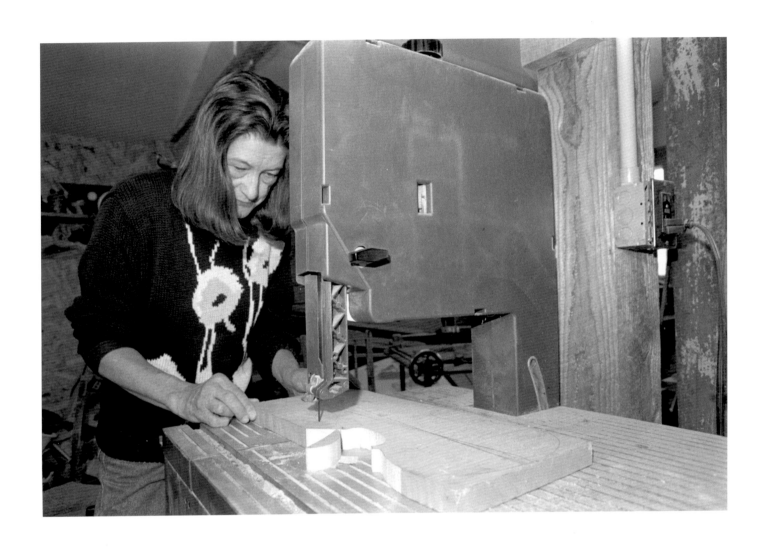

My daddy always told me that there just aren't any
shortcuts in this. He always said that if you figure
out a shortcut, then you'll just have a wall hanging.
You won't have a fiddle! …

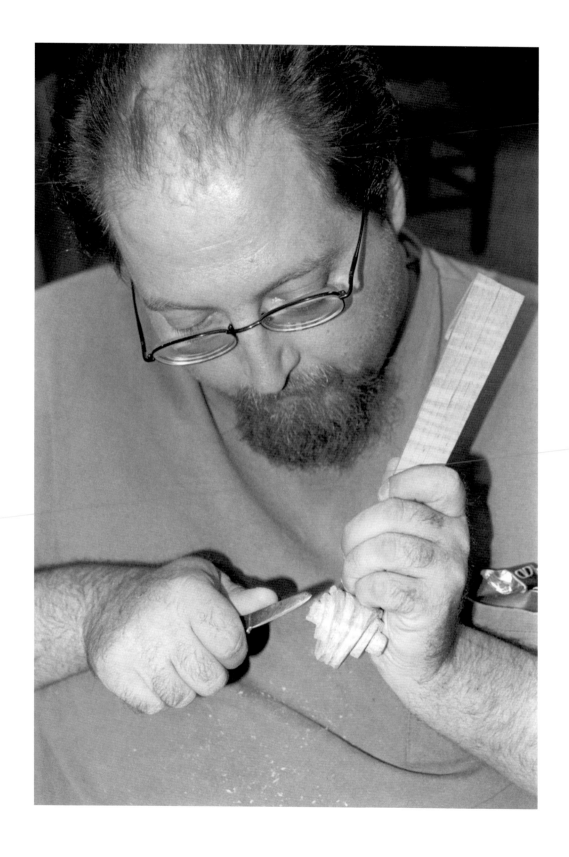

You see, this fiddle making, this is the thing that separates the men from the boys. Or I guess in my case you can say it's what separates the women from the girls! But seriously, if you don't love it, you're not gonna' sit around and carve something like this for days—and that's what it takes to do it. If you don't love this work, then you just won't do it!"

Audrey Hash Ham
Master Fiddle Maker

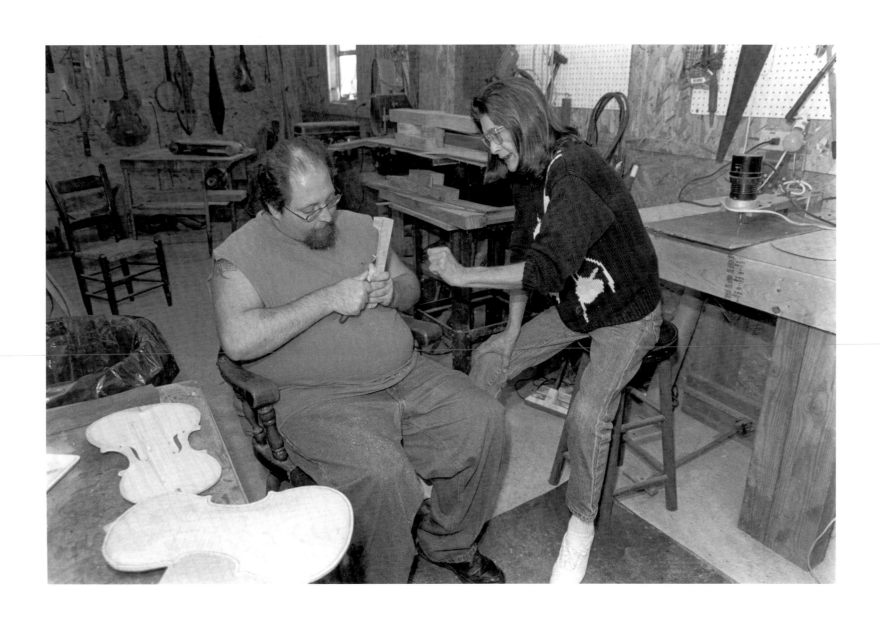

Tidewater Gospel Quartet Singing

Master Artists
The Paschall Brothers

Apprentices
Tarrence Paschall, Jr., et. al.

HAMPTON ROADS, the growing metropolitan area at the convergence of the James River, Atlantic Ocean, and the Chesapeake Bay, produced more than two hundred *a cappella* gospel quartets in the century following the Civil War, many of whom enjoyed international acclaim. Yet despite this illustrious history, there are only a handful of Tidewater quartets singing today. The Paschall Brothers, a stunning quartet from Chesapeake, are the current torch bearers of this proud tradition. The Paschalls are firmly rooted in a long tradition of fine Tidewater quartets, beginning with the Hampton Institute Quartette and followed by countless others, including the Silver Leaf Quartet, the Four Pennies, the Golden Crown Quartet, and perhaps most famously the Golden Gate Quartet.

The Paschall Brothers were formed by the Reverend Frank Paschall, Sr., in 1981. Reverend Paschall passed away in 1999, but his sons have carried on his legacy, performing regularly at area churches and for larger audiences at such prestigious venues as The Kennedy Center and Lincoln Center. Through their apprenticeship program, the Paschalls have expanded to include the next generation, recently adding apprentices Renard Freeman, Jr., and the late Reverend Paschall's grandson, Tarrence Paschall, Jr., to the group.

Our fathers and uncles have been singing for so long that we just kind of take to it. It's just a sound that's always kind of been there for us. And it's so different from the way they teach us in school. And me, I like it because it's loose. It's not in your face, you know, it's not "do this, do that, do this!" They still show you what to do, but they make it fun. They let you be yourself. They're kind of like us, really. They like to joke around and all. But when it's time to get serious, you know, it's time to get serious.

Tarrence Paschall, Jr.
Apprentice, Tidewater Gospel Quartet Singing

Old Regular Baptist Hymn Singing

Master Artist
Frank Newsome

Apprentice
Buster Mullins

THE SINGING OF THE OLD REGULAR BAPTISTS is one of the oldest and deepest veins of American spiritual singing traditions. This hymnody, with its elaborate, lined-out, unaccompanied singing is prevalent throughout the coalfield region of central Appalachia, but is barely known outside this region. It cannot be heard on television or radio, and is largely unavailable on recordings. Elder Frank Newsome, of Little David Old Regular Baptist Church outside of Haysi, Virginia, is one of the great masters of this singing style, which he uses to inspire his small but spirited congregation every Sunday. Frequent Little David attendee Dr. Ralph Stanley has been so enamored with Newsome's singing that he regularly invites him to sing at his annual music festival. Frank's singing has touched the hearts of many, but for his apprenticeship he worked most closely with fellow church elder Buster Mullins.

I most of all want to thank God Almighty that He's given me the gift that He has to sing, and if this will benefit Elder Mullins or anybody anything, if it will cause them to turn their sins unto the Good Lord, then it's worth every bit of it. I'm not doing this for no big name or pat on the back. I'm just an old country feller. I ain't got nothing and I ain't looking for nothing, but I believe I've got a home in Heaven when I leave here.

Elder Frank Newsome
Master, Old Regular Baptist Church Singing

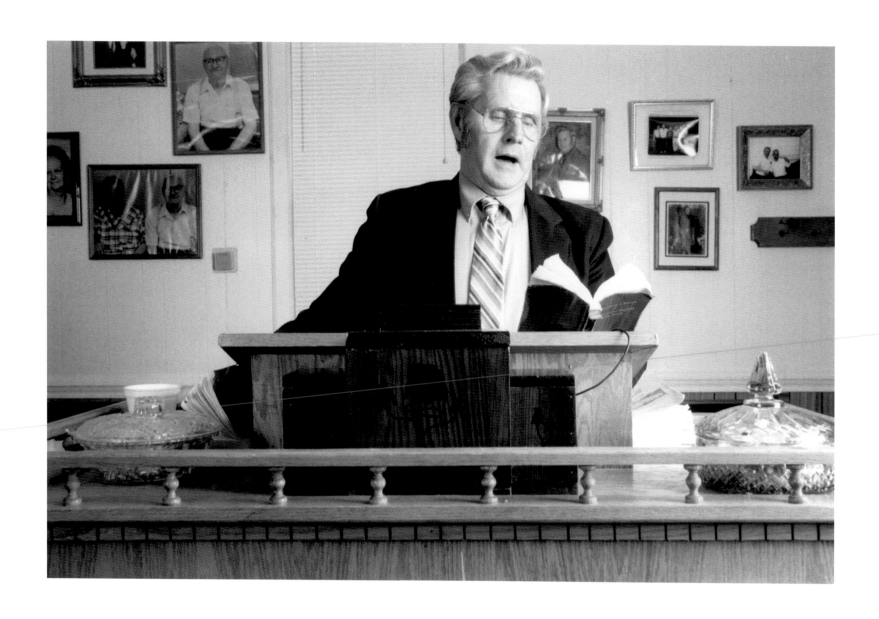

Bluegrass Mandolin

Master Artist
Herschel Sizemore

Apprentice
Spencer Blankenship

THE MANDOLIN WAS INTRODUCED to the United States by Italian immigrants in the 19th century, and was popularized by Bill Monroe, who featured the instrument as a cornerstone of his newly created country old-time hybrid, "Bluegrass." Virginia has been home to many of bluegrass music's "founding fathers," including National Heritage Fellows Ralph Stanley and Jesse McReynolds, and Roanoke's master mandolin player and composer Herschel Sizemore. Herschel's place in bluegrass history has been established with his composition of "Rebecca," perhaps the most popular mandolin contest song on the "fiddler's convention" circuit. Herschel taught "Rebecca" and many of his countless other compositions to Spencer Blankenship, one of the true emerging stars on the mandolin.

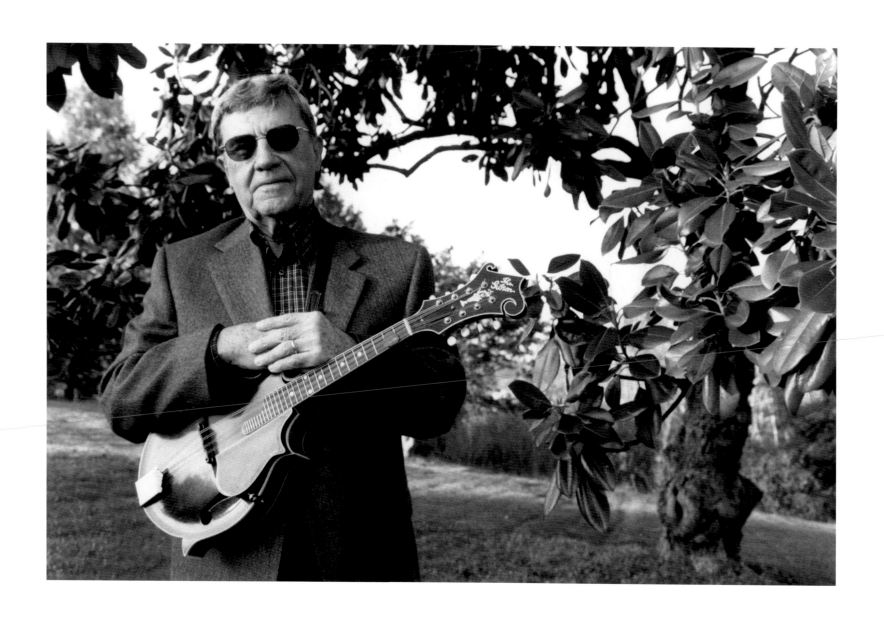

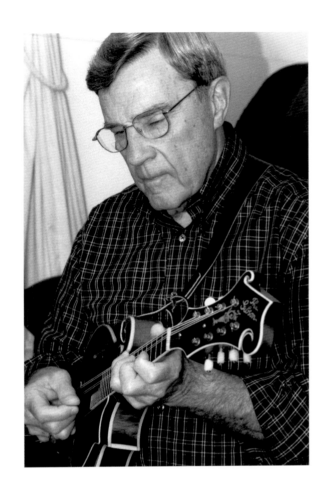

The way composing works for someone like myself who doesn't read music is like if one day you're sitting around doodling with a pen, and suddenly you get the inspiration to draw something. It just sort of just comes together for you. See, in bluegrass, written music sounds like written music. You could perfect it note-wise, but then you don't have the feeling or the little inflections. In bluegrass, what distinguishes players is their particular way of doing it, not so much of what, exactly, they're playing. So much of it is just feeling.

Herschel Sizemore
Master, Bluegrass Mandolin

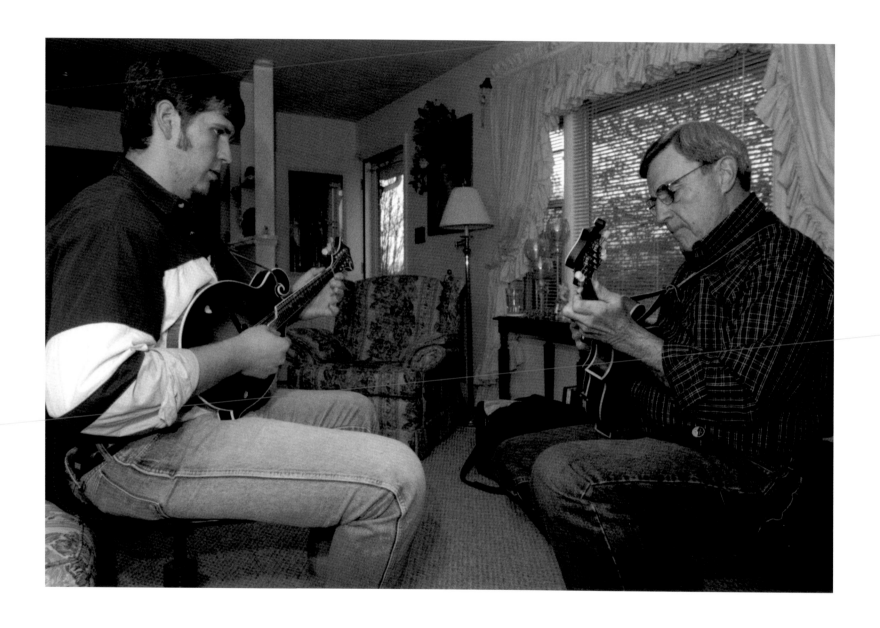

Irish Flute Making

Master Artist
Patrick Olwell

Apprentice
Aaron Olwell

THE FLUTE HAS LONG HELD A PROMINENT PLACE in traditional Irish music, but the practice of making flutes specifically for Irish music is relatively new. For many years, Irish musicians used flutes primarily designed for the classical tradition. This began to change late in the 1970s, as several masters began to design wooden flutes specifically for Irish music. Among these pioneering masters is Patrick Olwell. Patrick produces world-class wooden flutes from his shop in the tiny, Nelson County town of Massies Mill, in the upstairs of an old 1920s bank building. Patrick's flutes are much coveted and played by some of Ireland's finest musicians, including Seamus Egan, Matt Malloy, and the late Frankie Kennedy. Patrick has worked with numerous students, but none have shown the dedication of his apprentice and son Aaron Olwell.

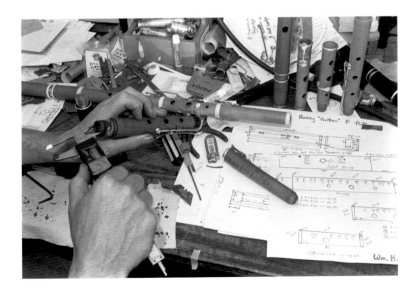

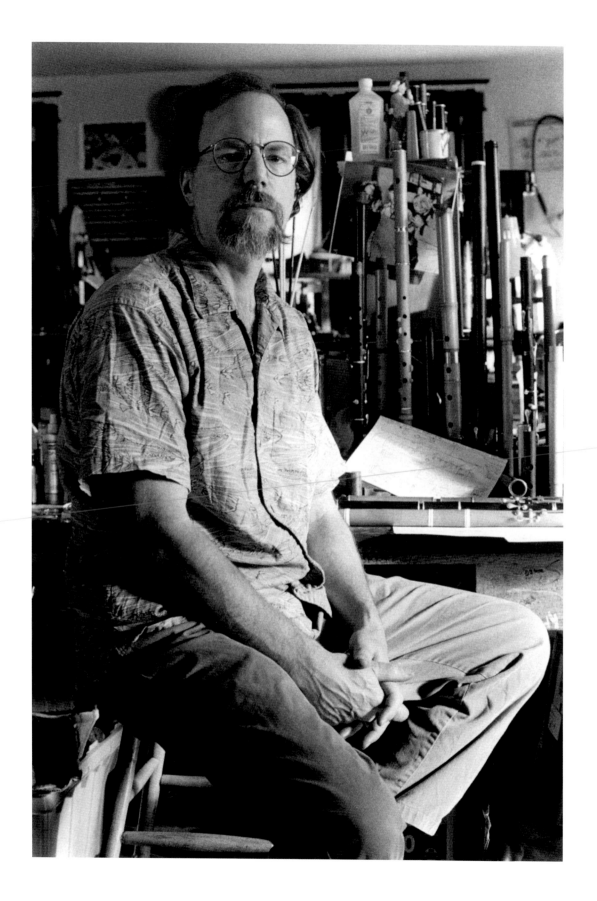

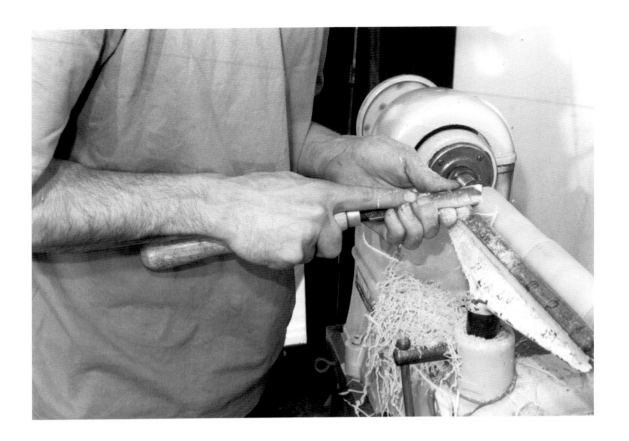

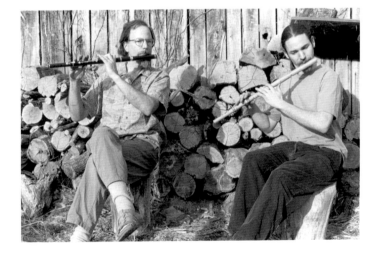

I never tried to push this on my sons. Of course, I always hoped that they would take an interest in music, but I never really imagined that Aaron would want to take up working with the old man. It's really a special thing, working everyday in the shop with your son. This is something that used to be quite common, but you just don't see it much anymore. It's allowed us to get to know one another in a completely different way.

Patrick Olwell
Master Flute Maker

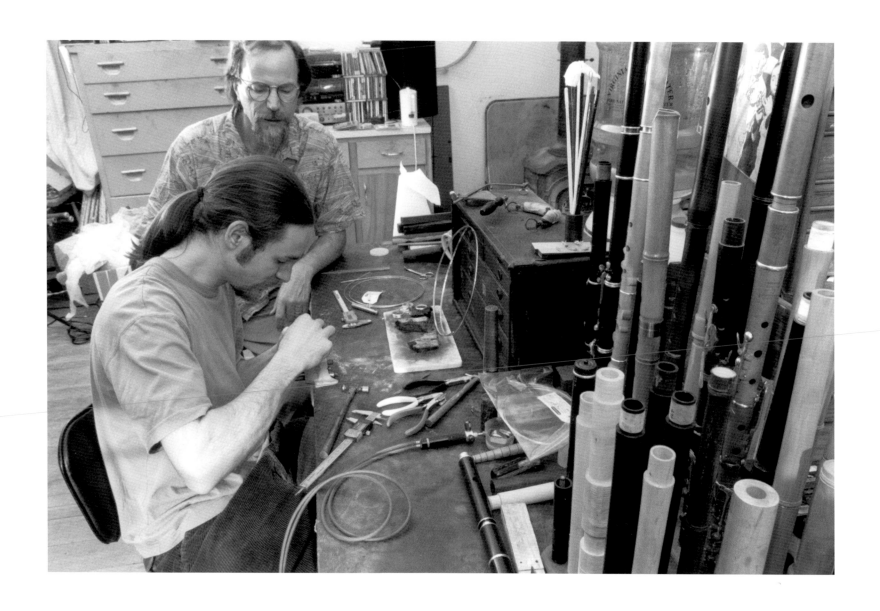

Powhatan Blackware Pottery

Master Artist
Mildred Moore

Apprentice
Bonnie Sears

THE PAMUNKEY INDIAN POTTERS HAVE BEEN CREATING their distinctive blackware pottery since before the first contact with Europeans in 1607. Born and raised on the Pamunkey Indian Reservation, Mildred Moore learned the art of traditional Powhatan Blackware as a child from the elder women at the pottery school. Mildred is now one of the few women still practicing this important tradition. She taught her apprentice Bonnie Sears to make the pottery using the hand-coil method without a pottery wheel, with clay processed from burnt mussels shells. The women dig their clay from the same vein in the Pamunkey River that has been used by the elder women of the Pamunkey for centuries.

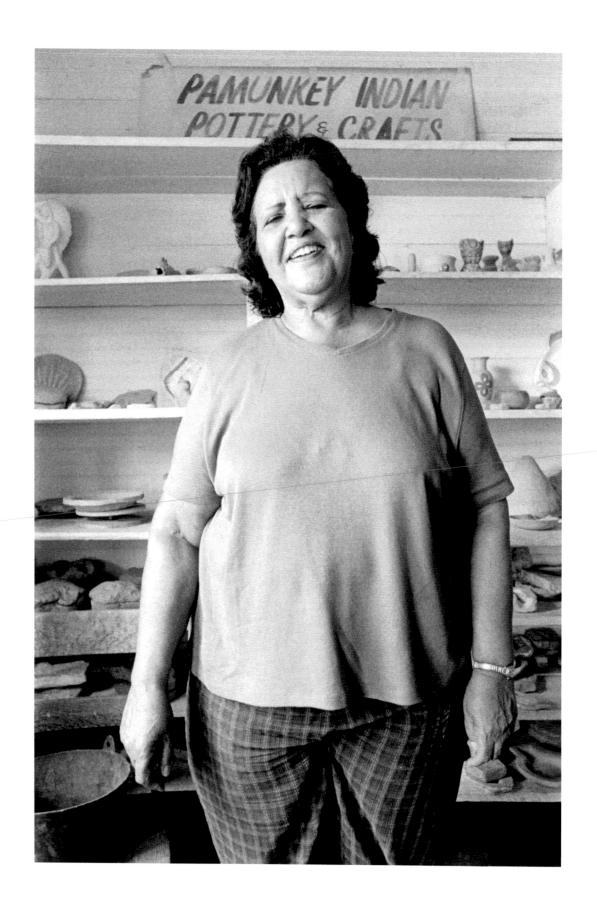

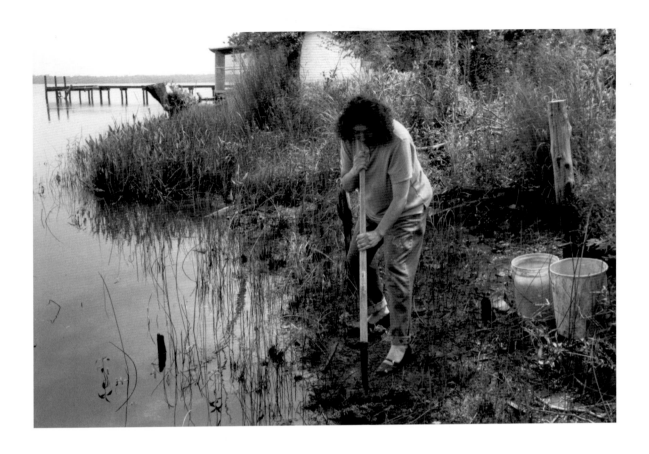

*I think everybody wants to get closer to their culture, to who
they are. Working with this clay is just one little piece of that,
but it's something that you can really touch. In our tribe
we've lost so much. This pottery is one of the few things we
have left. When it dies, a part of our culture will be gone forever.
That's why I want to learn all I can from Mildred. I want to
be sure that it keeps going.*

Bonnie Sears,
Apprentice, Pamunkey Indian Pottery

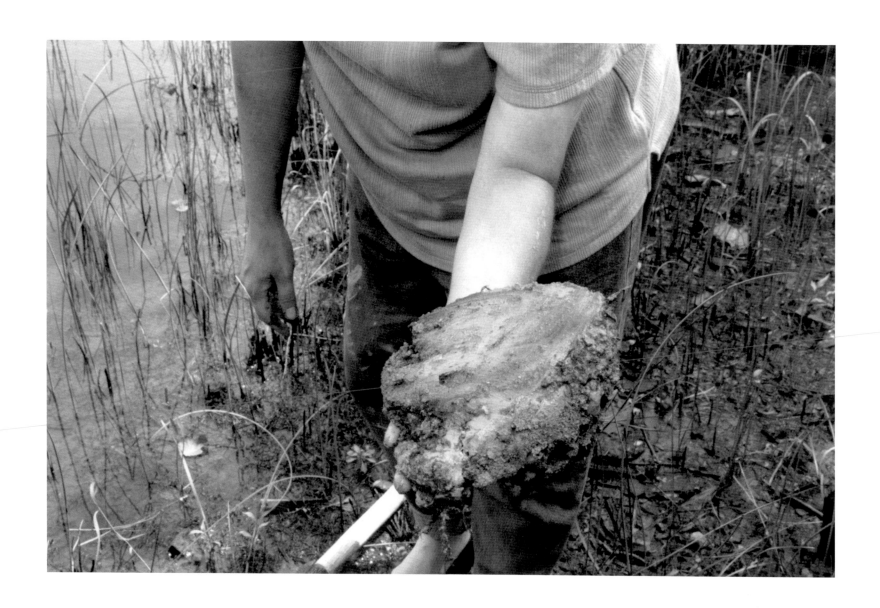

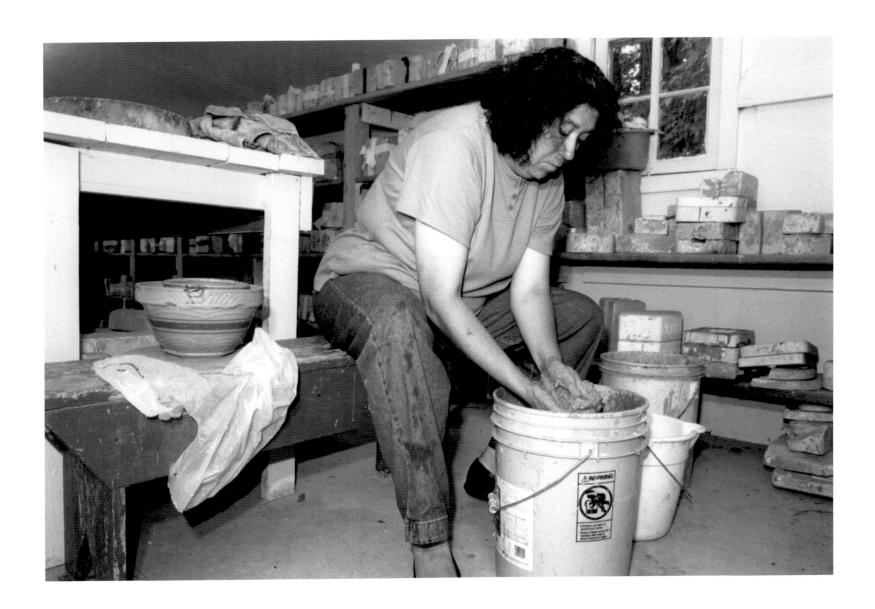

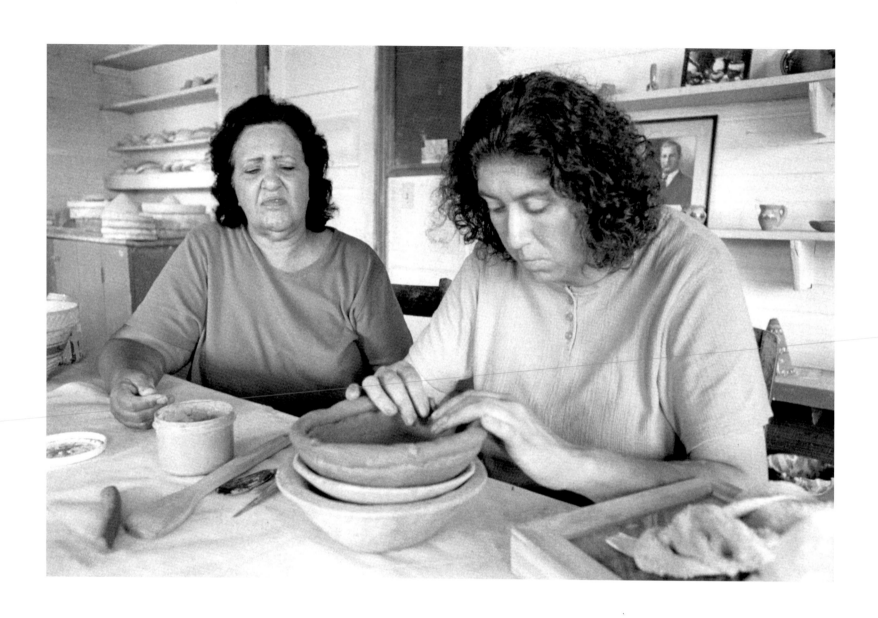

Flatfooting

Master Artist
Brenda Joyce

Apprentice
Shannon Joyce

FLATFOOTING, AN OLD-TIME DANCE STYLE closely associated with traditional string band music, is quite distinct from its closest cousin, clogging, in that the dancer's feet barely leave the floor. Distinct styles of flatfoot dancing remain remarkably local, and Patrick County, located on the eastern slopes of the Blue Ridge Mountains, has long been revered as a hotbed of flatfoot masters. Brenda Joyce grew up in the heart of Patrick County in the town of Stuart among some of the finest flatfooters, not the least of whom was her father, the legendary Hoy Haden. Hayden was a fixture at area dance floors and fiddler's conventions, winning countless blue ribbons at flatfoot competitions. While Brenda does not care to participate in contests herself, she entered the prestigious dance contest at the 2003 Galax Fiddler's Convention when her father was too ill to compete. She came home with the blue ribbon. Hayden passed shortly thereafter, and Brenda has never defended her title. Hayden's buoyant dancing steps live on today in Brenda, as well as in the fleet feet of her apprentice and daughter, Shannon Joyce.

My daddy was a great dancer, probably considered one of the best this area has ever seen. I learned to dance from him, but I developed my own steps, my own style. That's how I'd like Shannon to learn. I want her to carry this on, but in her own way.

Brenda Joyce
Master Flatfooter

West African Dance

Master Artist
Ofosuwa Abiola-Tamba

Apprentice
Monica James

WHILE THERE IS NOW A GREATER UNDERSTANDING and appreciation of the African origins of much of Virginia's expressive culture, these roots were long ignored, misunderstood, or held in diminished regard in comparison to the impact of European folk traditions. Interest in the teaching and learning of West African folk traditions, particularly story telling and dance, emerged as an integral part of the civil rights and black pride movements in urban areas throughout the country, including Virginia. Ofosuwa Abiola-Tamba has studied traditional African dance for 40 years, working to articulate aspects of African culture through the story of the dance and music. She has taught thousands of students in a variety of settings, and currently directs the Suwabi African Dance Ballet in Hampton Roads. Ofosuwa has traveled extensively to Africa to develop her craft, and recently visited The Gambia with her apprentice, Monica James, to learn dances from the Jola Culture.

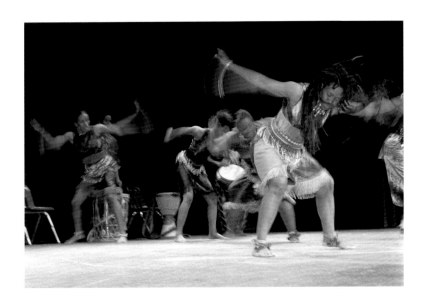

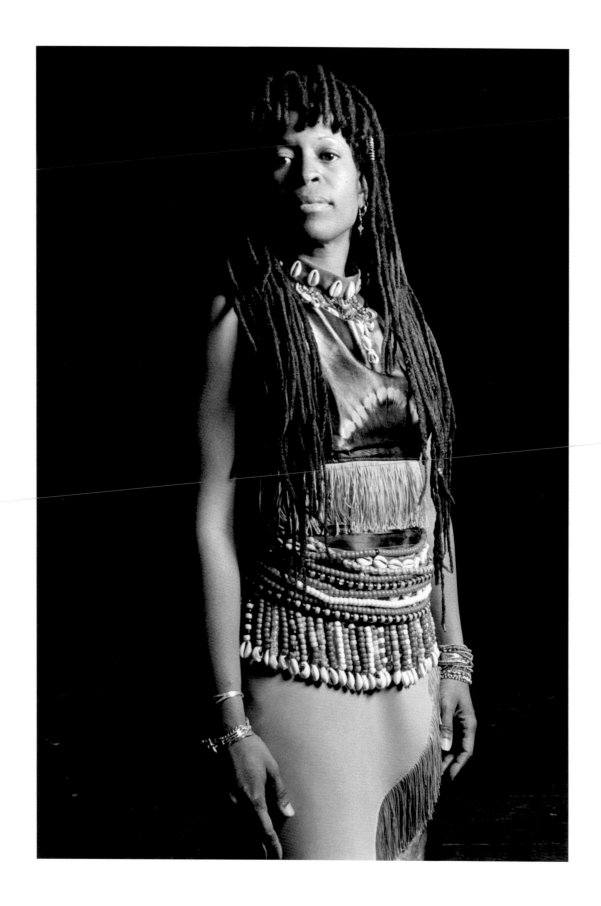

It's special. Every dance we do, all of the costumes, everything has a meaning and a history. Ofosuwa is a great teacher, and has a great knowledge of the history. I like that we're not just dancing, we're doing something ancient that has symbolic value. It makes me feel more connected to my culture.

Monica James
Apprentice, West African Dance

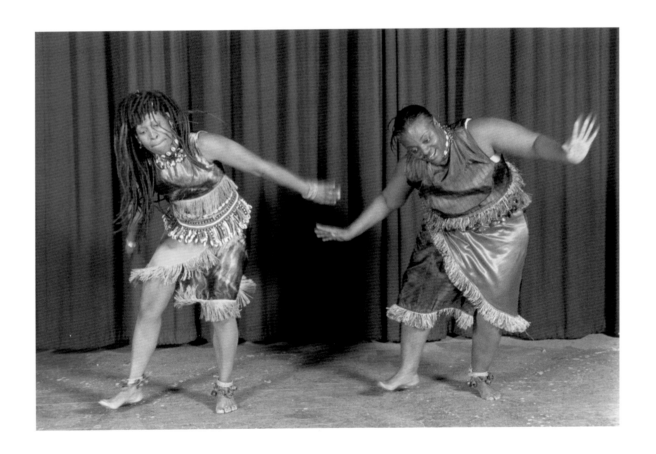

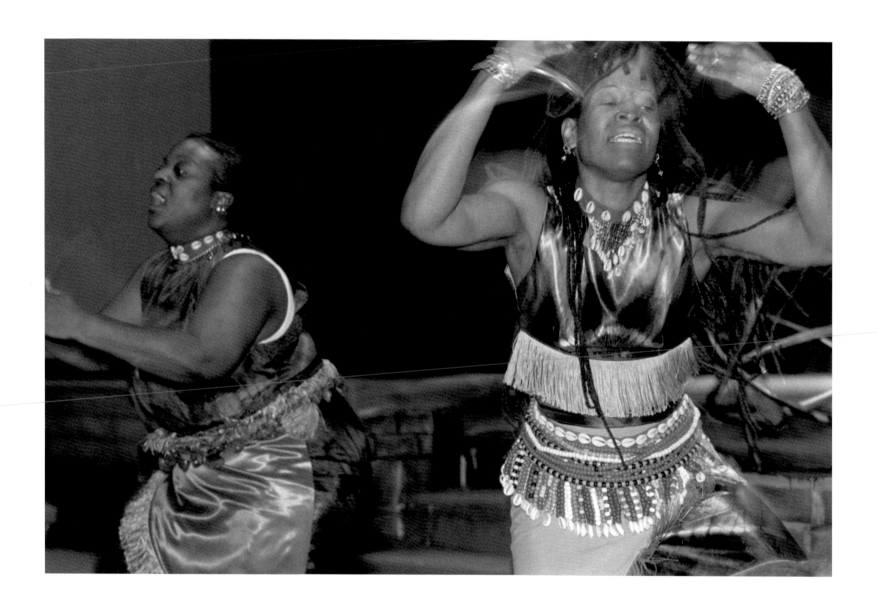

Old-Time Banjo

Master Artist
Mike Seeger

Apprentice
Seth Swingle

MIKE SEEGER HAS DEVOTED HIS LIFE to singing, playing, studying, teaching, and documenting the old-time music of the southern Appalachian Mountains. Over the years, Mike has absorbed a wide range of traditional styles of music through direct association with master musicians such as Elizabeth Cotten, Maybelle Carter, Dock Boggs, and many others. He is a founding member of the vanguard old-time string band, the New Lost City Ramblers, which was formed in 1958. Making his home in Lexington, Mike has long been one of the area's most beloved musicians, and this past year he was honored with a "Lifetime Achievement Award" from the National Folk Alliance. His young apprentice, Seth Swingle, is a gifted banjoist and accomplished musician in his own right.

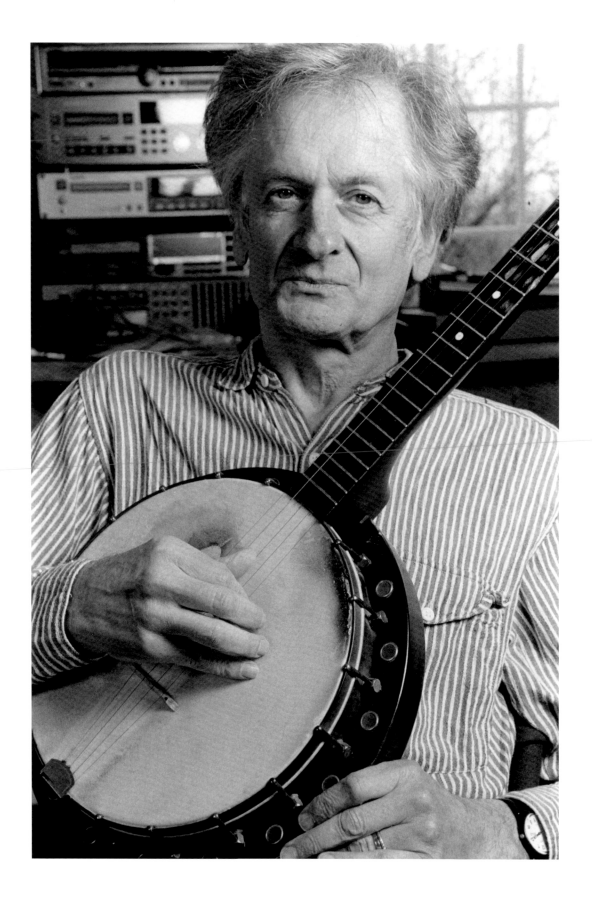

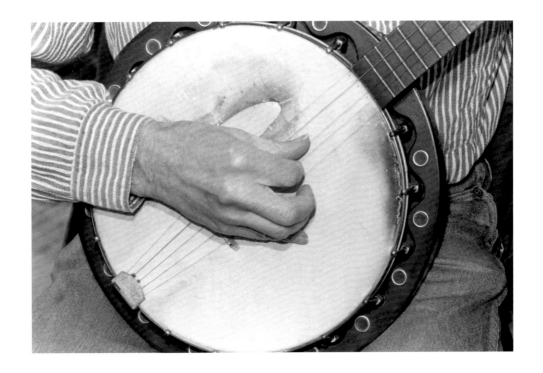

It has been the mission of my life to preserve this music in a living way. It is a valuable and continuing heritage that is being threatened by the mass media. We have to go to extra lengths to give it a boost, which is one reason that things like the apprenticeship program are so important.

Mike Seeger
Master Old-Time Musician

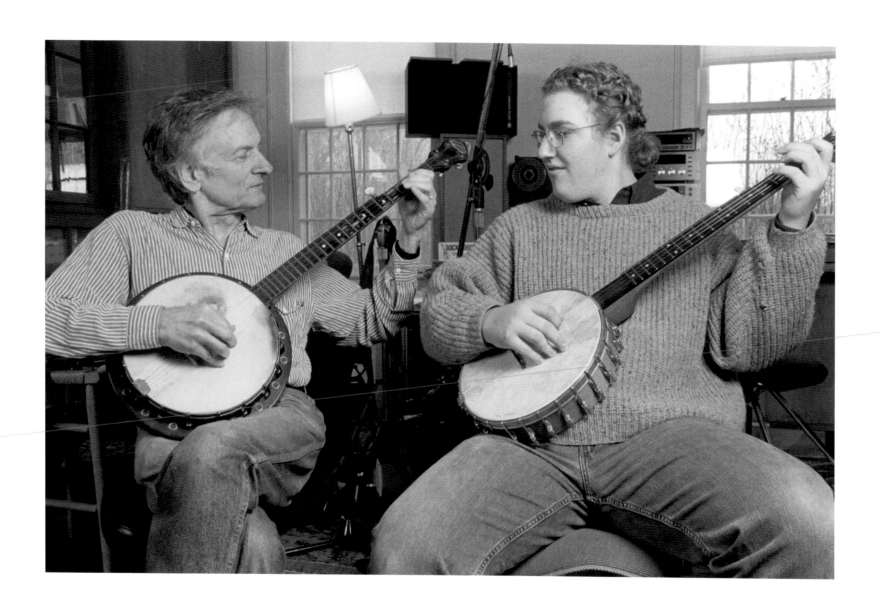

Blacksmithing

Master Artist
William Rogers

Apprentice
Amin Ghaderi

WILLIAM ROGERS USES A COAL-FIRED FORGE, an anvil, and some time-tested hand tools to perpetuate the centuries-old skill of blacksmithing. Exposed to the craft at an early age, William recalls times growing up on a farm when his grandfather used traditional metal-smithing tools and techniques. William has since made his living educating others about the craft he loves. He has taught extensively in Virginia, Tennessee, and North Carolina, and he even spent a semester instructing in Panama. When touring the state as a part of the Virginia Museum of Fine Arts Series, William captivated audiences with his demonstrations. Being selected for this award provided William the opportunity to teach in the master-apprentice style, which he sees as ideal. Blacksburg native Amin Ghaderi, anxious to improve his already impressive metalworking skills, served as William's apprentice.

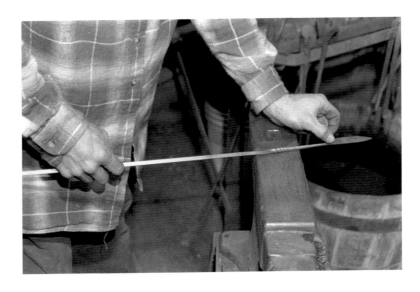

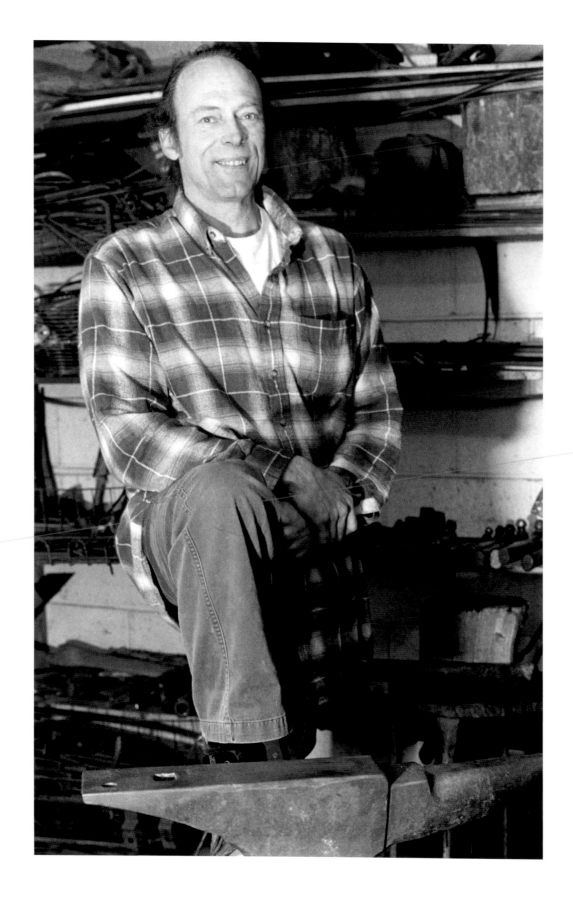

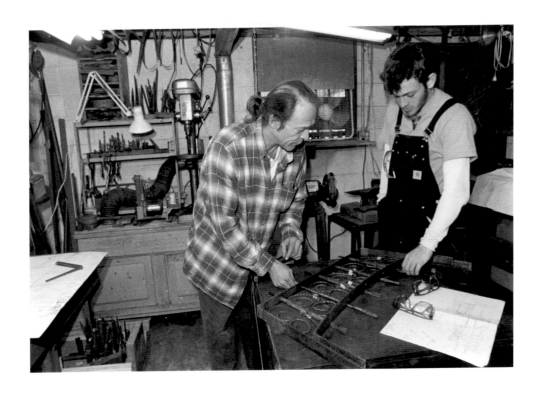

*I see the objects that I make as not so much the goal in itself
but as a kind of visual record of the actual act of making it.
You know, for a performing artist, like a singer, there's only a
product if somebody records the performance. And it's the same
way for me. It's live action, and the finished product is just
a record of this real genuine thing that happened. And this
is particularly the case when it's two people working together.
It's a dance and a song.*

William Rogers
Master Blacksmith

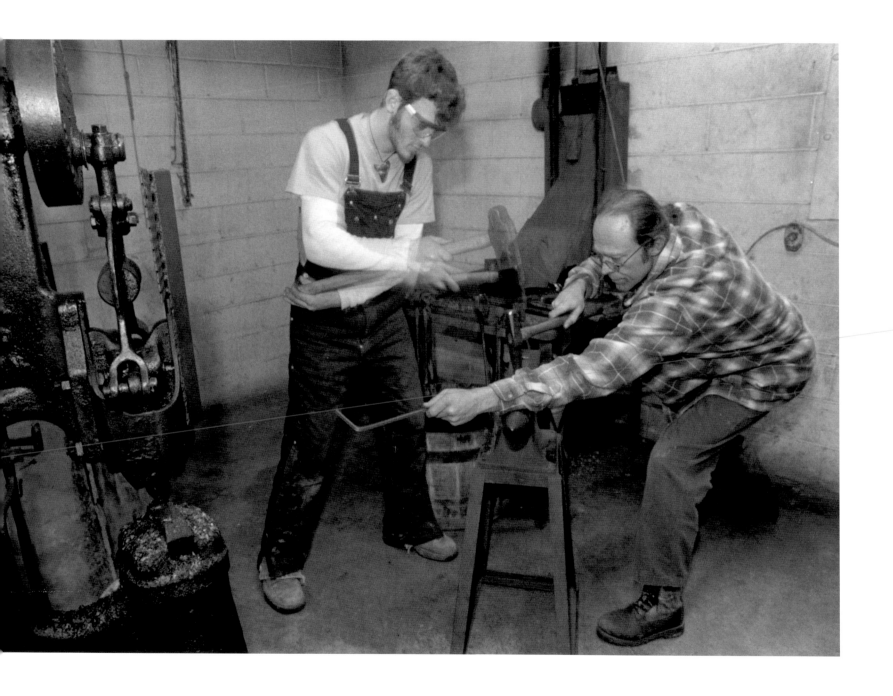

Mandolin Making

Master Artist
Gerald Anderson

Apprentice
Spencer Strickland

SOUTHWEST VIRGINIA HAS ALWAYS HAD a rich tradition of luthiers— the builders of stringed, fretted instruments, and mandolin maker Gerald Anderson is considered among today's true masters. Gerald spent more than thirty years apprenticing in the shop of legendary guitar and mandolin builder Wayne Henderson, and has spent several years teaching the craft to his young apprentice Spencer Strickland. Spencer entered his apprenticeship with the distinction as one of the region's finest mandolin players, and has also been a quick study in the instrument's construction. Gerald and Spencer's apprenticeship has led to both a performing and building partnership, and their mandolins are now coveted for their intricate handiwork and warm tone by musicians throughout the world.

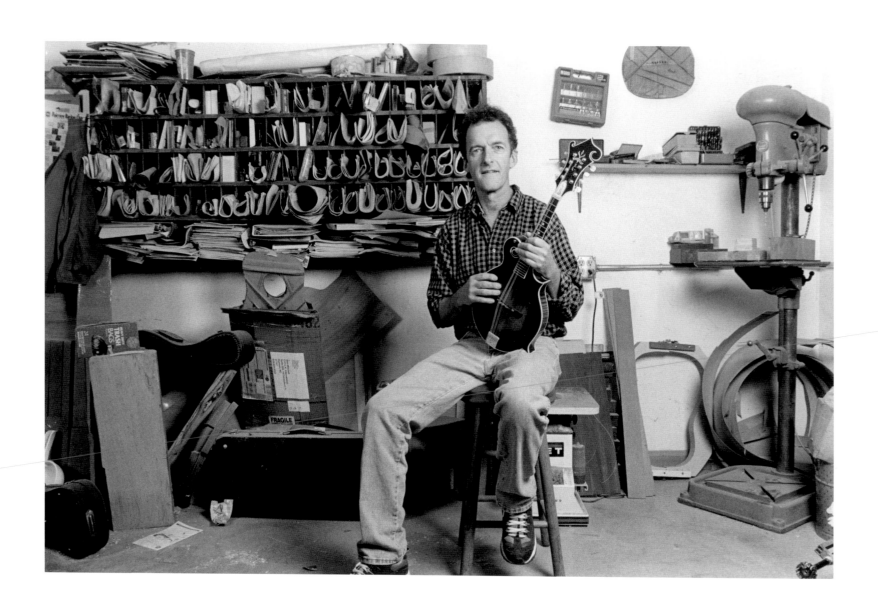

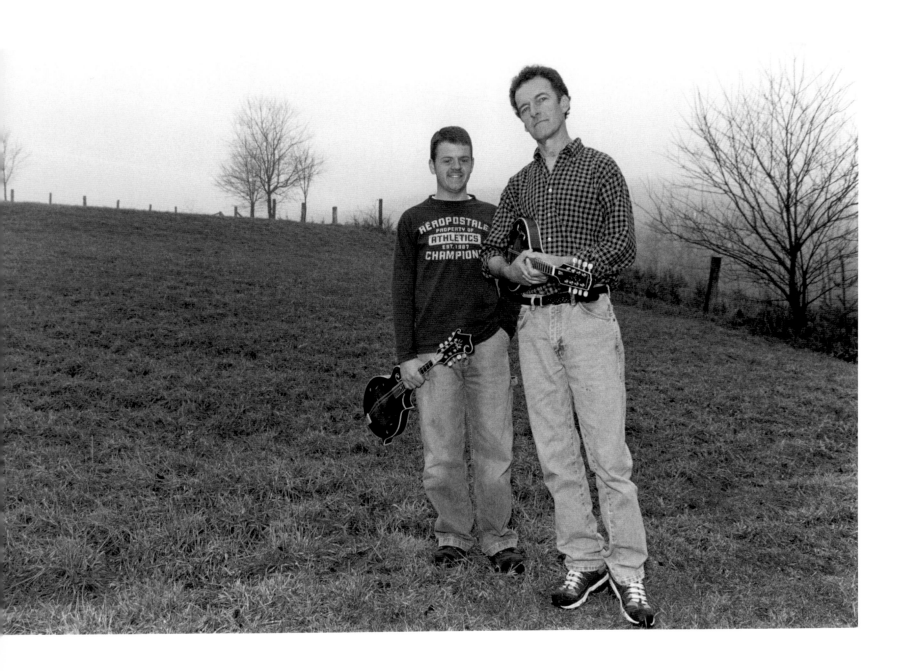

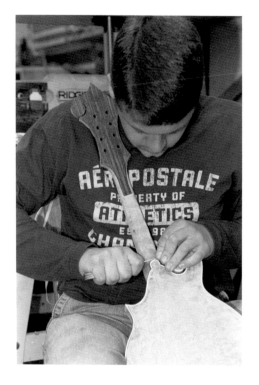

Big companies make good mandolins. They're perfect every time. But I once heard someone say that an instrument made by a computer has the warmth of a computer, while one that's made by hand has the warmth of the maker, and I'd agree. I'd prefer something to be made by someone I know over a machine-made instrument any day.

Gerald Anderson
Master Mandolin Builder

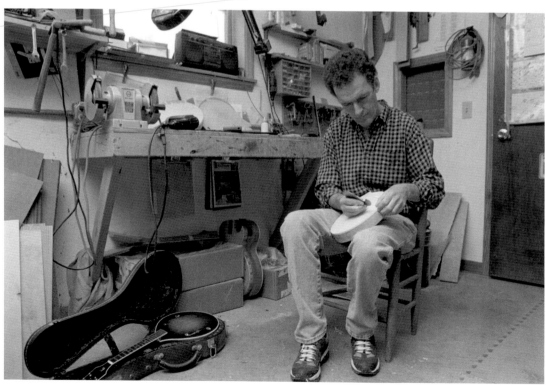

African American Shout Band

Master Artists
The Madison
Hummingbirds

Apprentices
"The Rookies"

IN 1903, AN AFRICAN-PORTUGUESE IMMIGRANT named Marcelino Manoel da Graca (Charles Manuel Grace), the son of a stonecutter from the Cape Verdean Island of Brava, came to the southeastern Massachusetts town of New Bedford. "Daddy Grace," as he became known, was a dynamic spiritual leader who started the United House of Prayer. The United House of Prayer congregation eventually reached up and down the East Coast, with one of its first and most successful churches in Newport News, Virginia. One of the hallmarks of United House of Prayer church services, baptisms, funerals, and parades is the exclusive use of brass instruments, inspired by the words of Psalm 150: "Praise ye the Lord. Praise Him with the sound of the trumpet." The United House of Prayer brass bands came to be known as "shout bands" because of their ability to move entire congregations to shout with heartfelt spiritual energy. The Madison Hummingbirds, of Portsmouth, are the current torchbearers of the great Virginia shout band tradition. As has been the case for generations in the House of Prayer, they have been carefully bringing along "The Rookies," a group of young men that will compose the next generation of Hummingbirds.

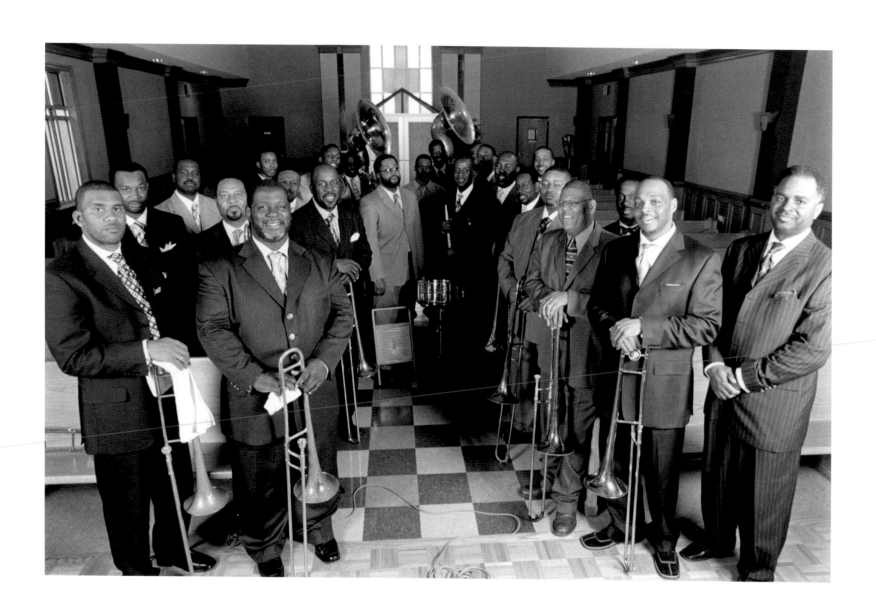

131

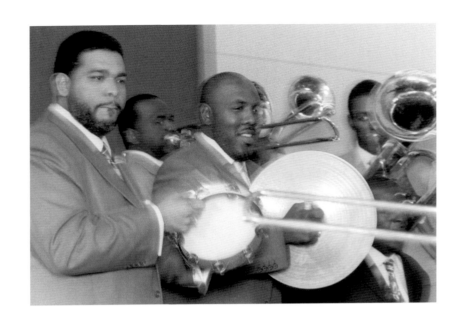

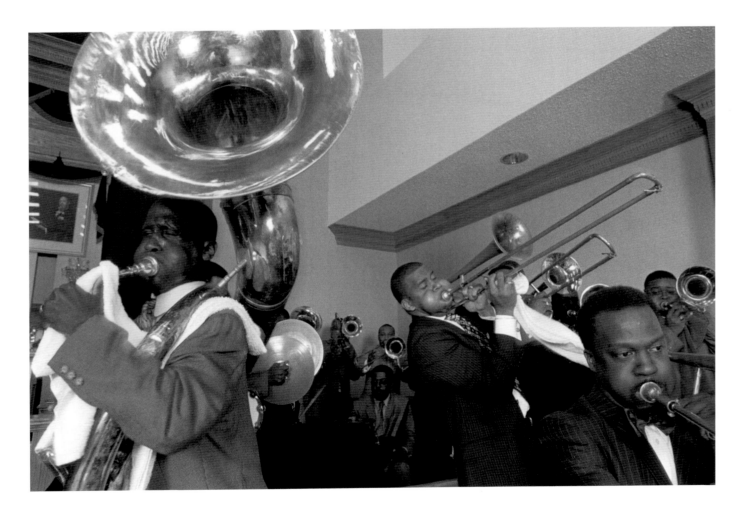

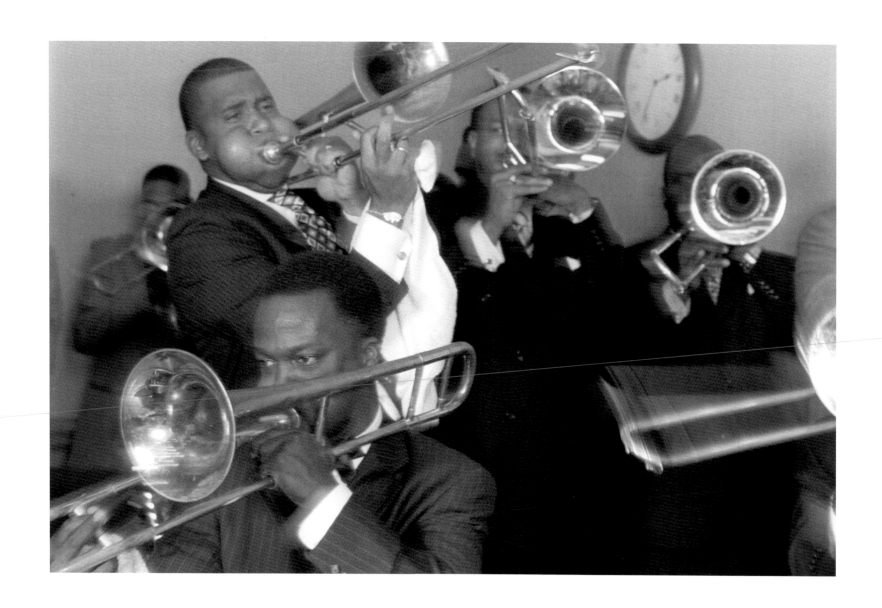

We call the young guys "the rookies." They're coming up just like we did. That's how it's always been in the House of Prayer. We all grew up in this sound, literally from the time we were babies. I'm just glad that the young guys are still into it, that they still want to learn. We're always ready to welcome guys like that into the Hummingbirds.

Bradley Sunkins
of the "Madison Hummingbirds," United House of Prayer

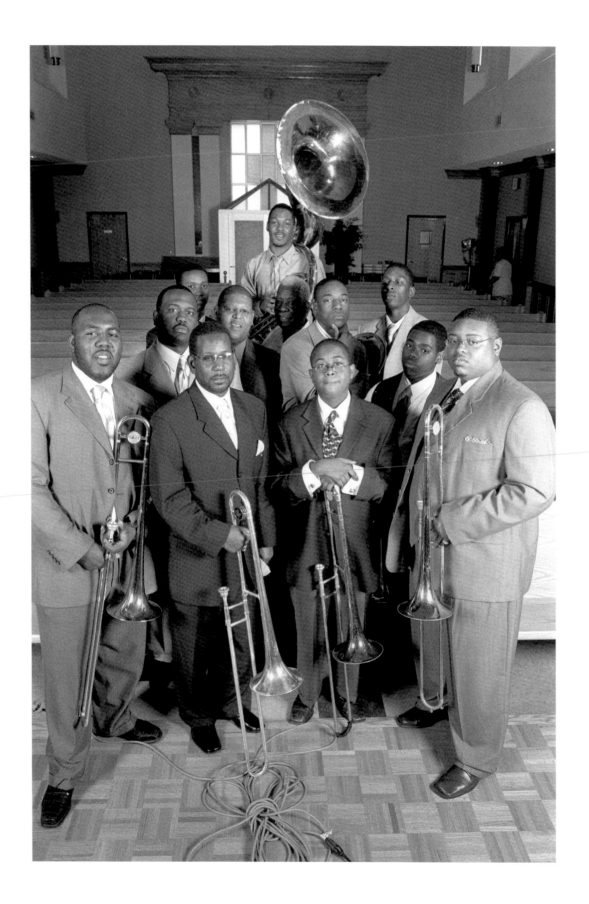

Corn Shuck Doll Making

Master Artist
Ganell Marshall

Apprentice
Sarah Mullins

A VERSION OF CORN SHUCK DOLL MAKING was likely first introduced to settlers in Southwest Virginia by Native Americans, though it was also a staple craft of early Mission Schools in the region. The art of "Corn-shuckery" resonated with many Appalachians, as they had already grown accustomed to creating most of their clothing, tools, and even toys by hand. Relying on a family heritage of traditional skills such as woodworking, spinning, weaving, and stitchery, Ganell Marshall has been using native materials to create corn shuck and apple head dolls for more than forty years. Ganell has known her apprentice Sarah Mullins since Sarah was a young girl, and has always been impressed with her interest in carrying on this increasingly rare craft.

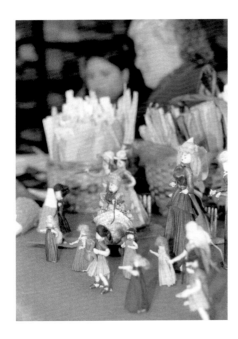

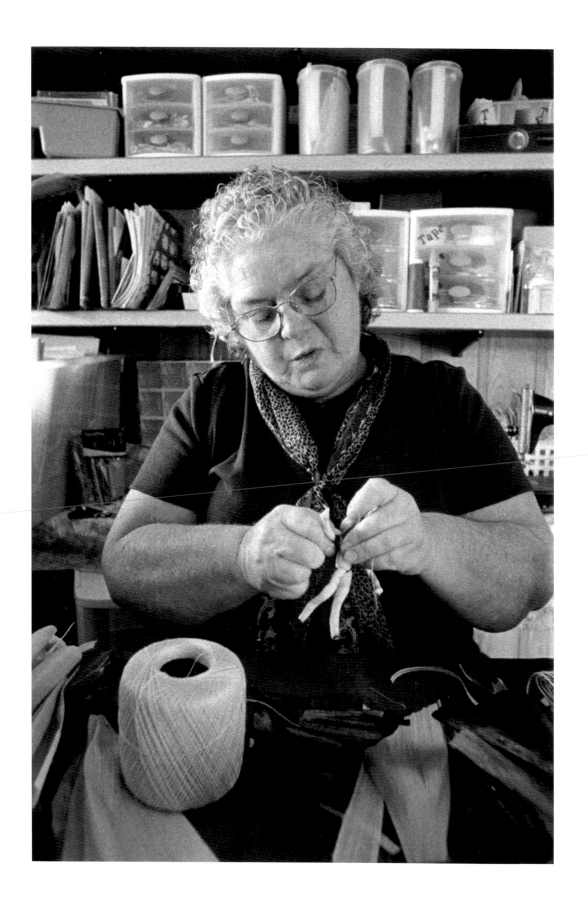

I always wanted to learn this, ever since I saw a doll that Ganell had made. And I started to notice that more and more it seems like people in this area don't appreciate their heritage. In fact, I can't think of anyone I know in my high school who seems interested in this sort of thing. But I think they're missing out. Making these corn shuck dolls, it can be hard in parts. But it seems like the more I work at it, the easier it gets.

Sarah Mullins,
Apprentice, Corn Shuck Doll Making

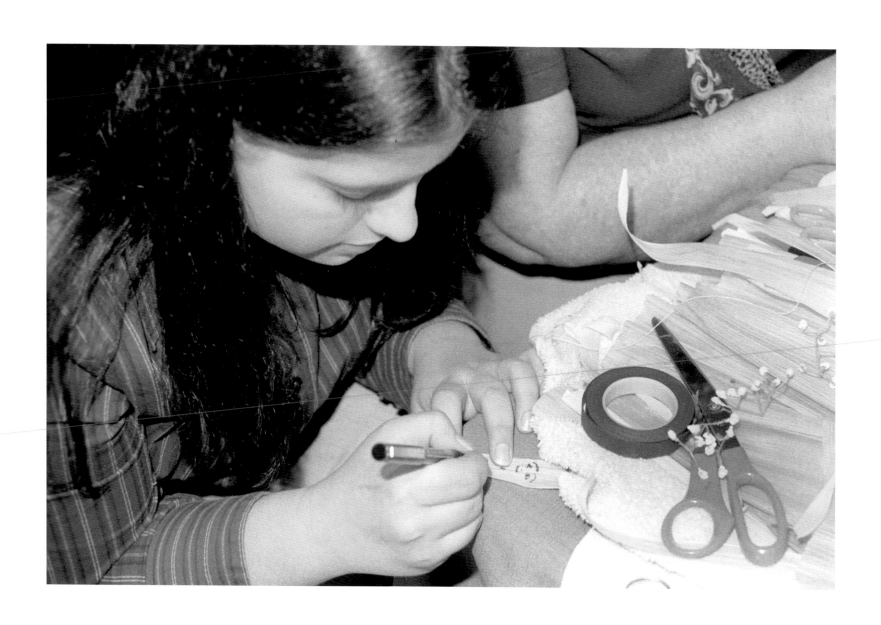

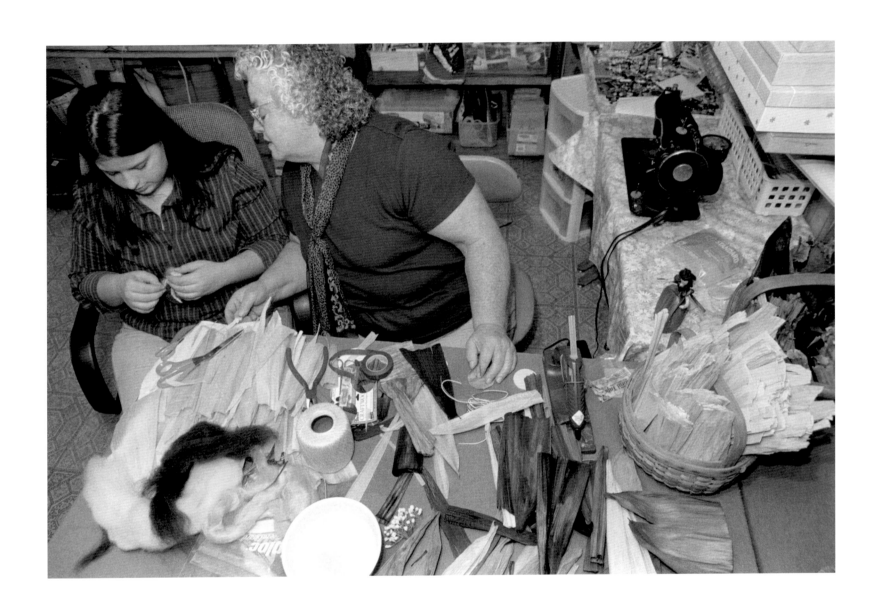

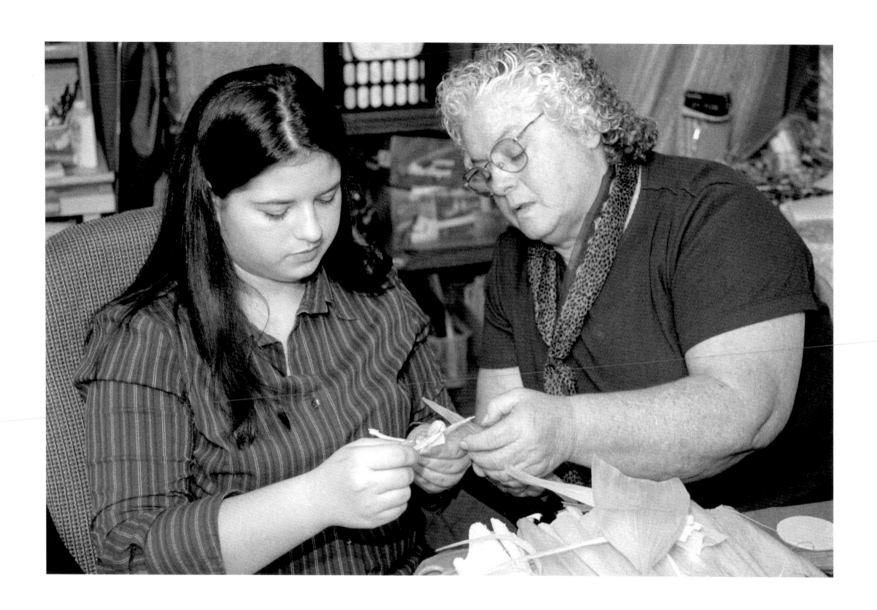

Automobile Pinstriping

Master Artist
Tom Van Nortwick

Apprentice
Andrew Elder

TOM VAN NORTWICK OF FRANKLIN COUNTY is Virginia's master of pinstriping, the precise application of a thin line of paint to create designs on auto body panels. Tom grew up in the mid-1950s around hot rod auto riggers and played around his neighbor's race car. Tom saw his first auto races during visits to his father, a mechanic and artist living in California. It was on these visits that Tom first saw the designs of Kenny Howard, a.k.a "Von Dutch," generally considered the founding father of pinstriping. Years later, Tom started "ripping" his own designs at the encouragement of master hot rod rigger John Rinehart. Tom has since become a legend of the craft in his own right, and cars bearing his designs have been featured in countless national magazines. Tom had his young apprentice, Andrew Elder, have ample canvas to practice on in Andrew's father's Staunton, Virginia, antique auto shop.

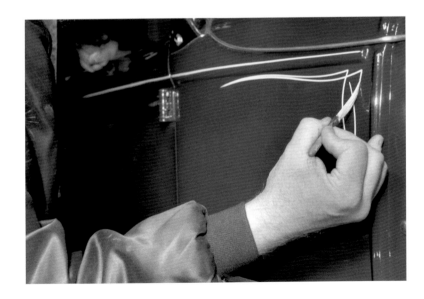

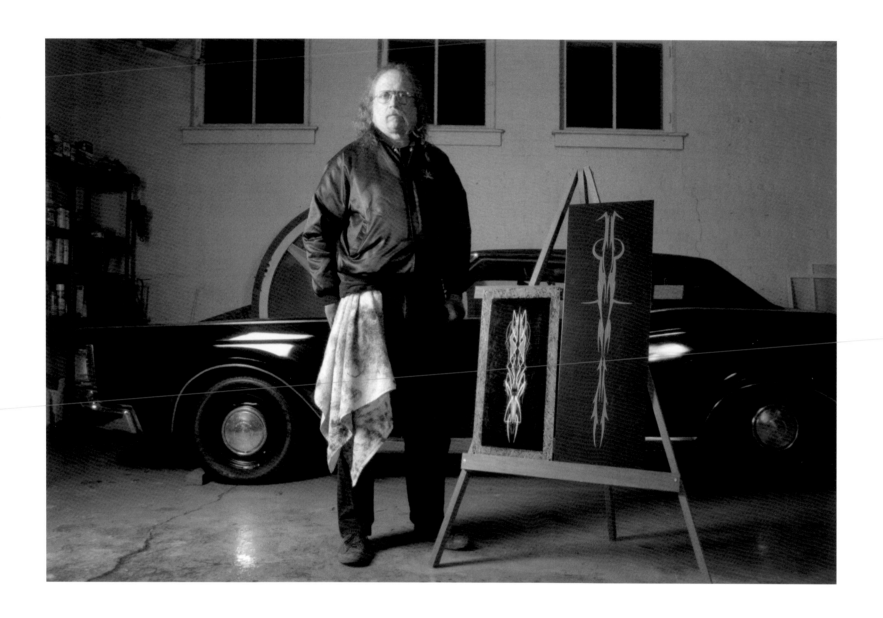

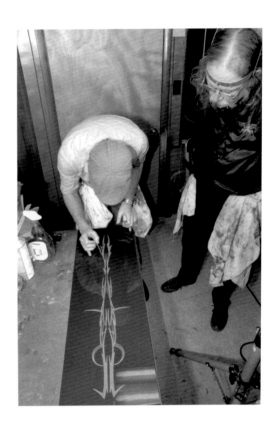

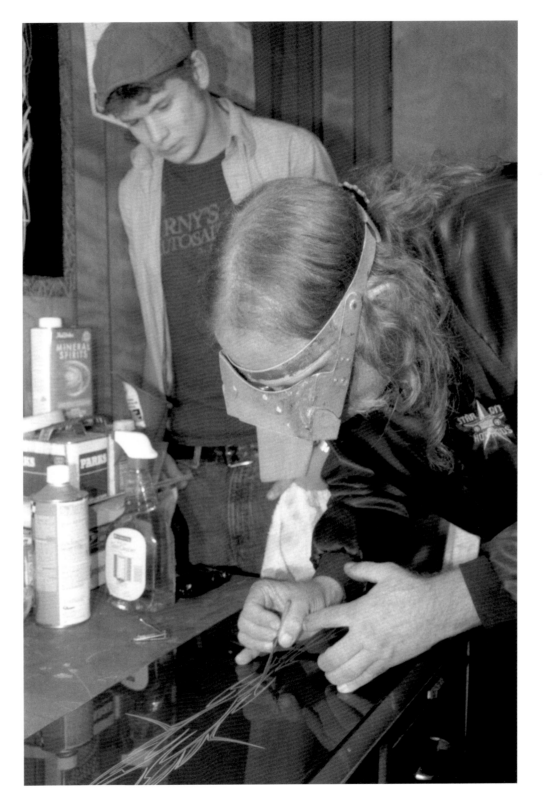

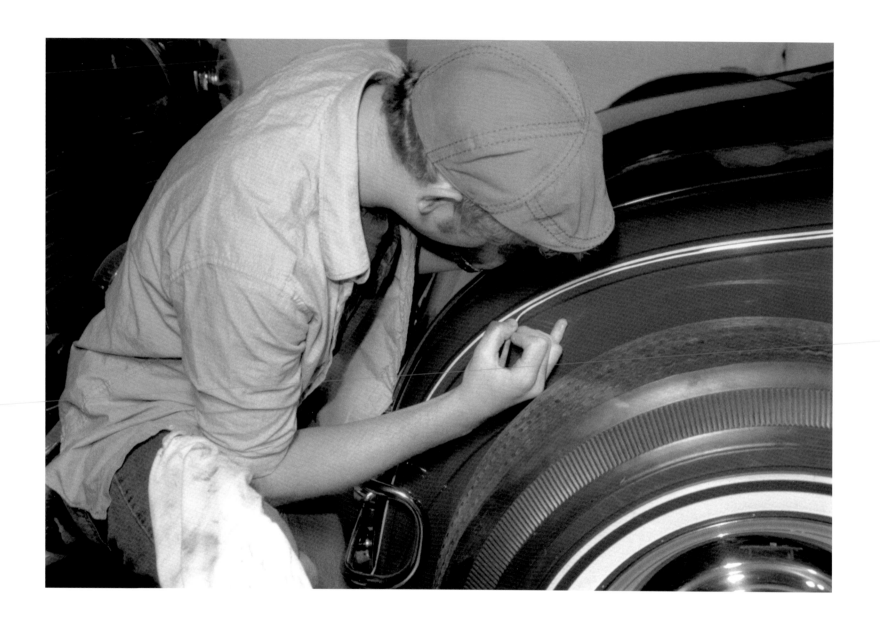

A guy called me to do his car and he said, "Do you have all colors of tape?" I said, "No, I don't use tape, I only use paint." He never knew that these were actually lines painted by hand. See, very few people know what pinstriping is. But it's an art that goes back thousands of years, even to the chariots and to ancient Egypt….

When I learned how to do this, I saw guys at car shows pinstriping, and I got some of my first designs from them. The main thing to do is get a straight line. Everything is based on that, and then the design stuff comes later. Everybody's got to get their own style after they can paint a straight line.

Tom Van Nortwick
Master Pinstriper

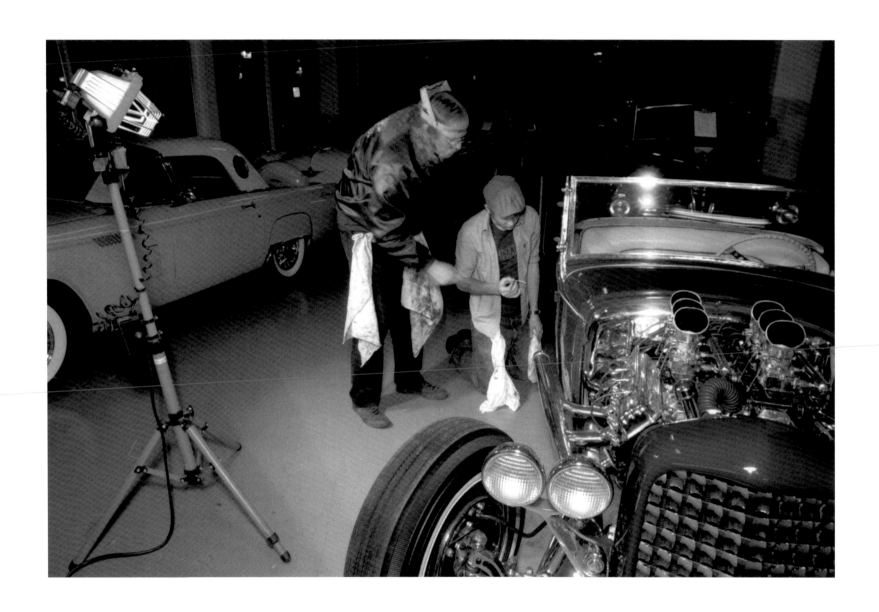

Steel Drum Making

Master Artist
Elton Williams

Apprentice
Earl Sawyer

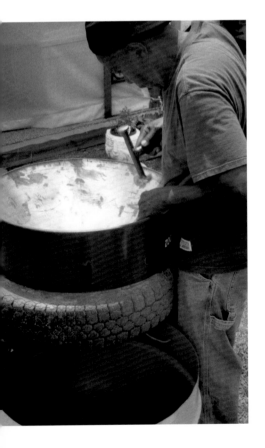

THE STEEL DRUM, OR "PAN" as it is called in the Caribbean, was invented in Trinidad about the time of World War II. Afro-Trinidadians resourcefully crafted this musical instrument out of oil drums left behind by the U.S. Navy. Contemporary pans are created when a 55-gallon steel oil drum is hammered concave, a process known as "sinking." The drum is then tempered and notes are carefully grooved into the steel. The pan has become a national symbol for Trinidadian Independence and the signature instrument in the Caribbean Carnival season. Hampton resident Elton Williams grew up in the pan yards of Trinidad, and has since immersed himself in every aspect of steel bands. He is a musician, composer, tuner, and now one of the few steel pan makers in the United States. Since moving to Virginia, Elton has been very active in the Caribbean community in Hampton Roads, and is the director of the Caribbean Music Information Center. Elton enjoys teaching others to make pans, and his apprenticeship allowed him to work more closely with his prize student, Earl Sawyer.

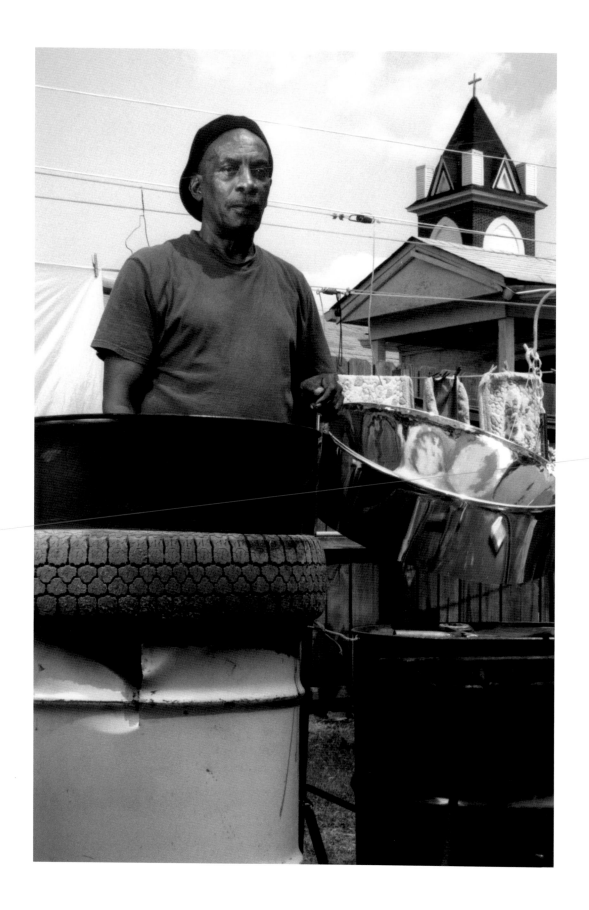

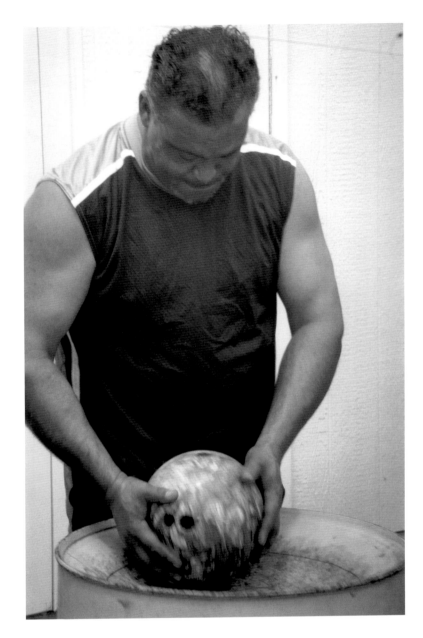

Making the pan is hard, physical work, especially sinking the drum. But when you bring the drum to the point where you can actually hear it playing … well, that's the feeling of the whole thing. It's a kind of freedom, a feeling of "this is my thing." And you know that you've accomplished something that not many people can do.

Elton Williams
Master Steel Drum Maker

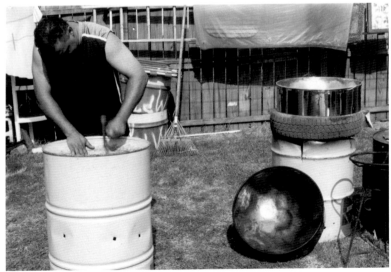

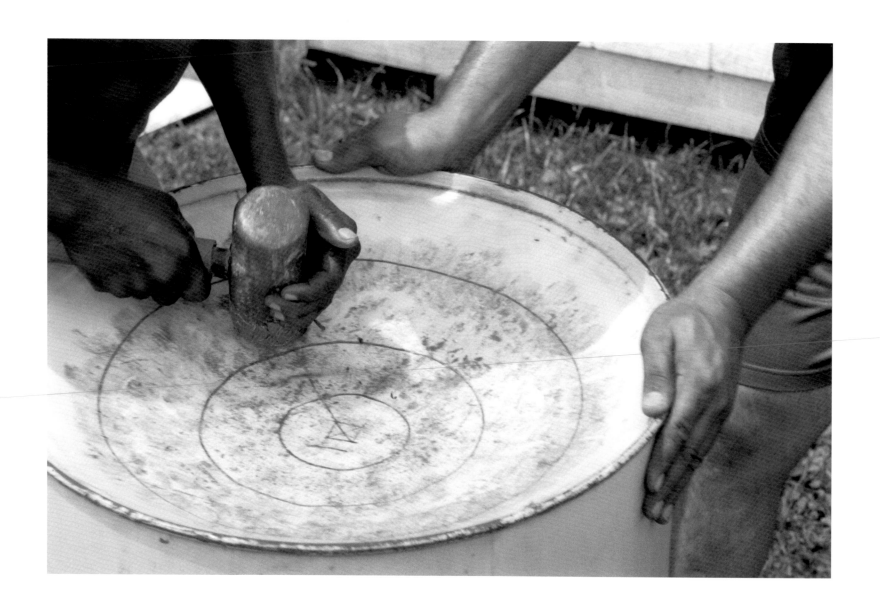

Appalachian Song

Master Artist
Spencer Moore

Apprentice
Ben Moore, Jr.

When the late folklorist Alan Lomax set out on one of his legendary "Southern Journeys" in 1959, he stopped in Chilhowie, Virginia, to record a tobacco farmer named Spencer Moore in his small, tar paper house. Spencer was quite well known locally for his weekly appearances on the "Farm Fun Time" radio program out of Bristol, which showcased his spirited singing and guitar playing. Spencer enthralled Lomax, who was particularly impressed with the sheer breadth of Spencer's repertoire. Almost fifty years later, Spencer still lives in the same house in Chilhowie, and while he no longer farms tobacco, he plays regularly at weekly jams and dances throughout the region. No one can say for sure how many songs Spencer Moore knows, but suffice it to say that it is well into the thousands. Many of these songs are not written down or recorded, making Spencer's apprenticeship with his great-nephew, Ben Moore, Jr., even more significant.

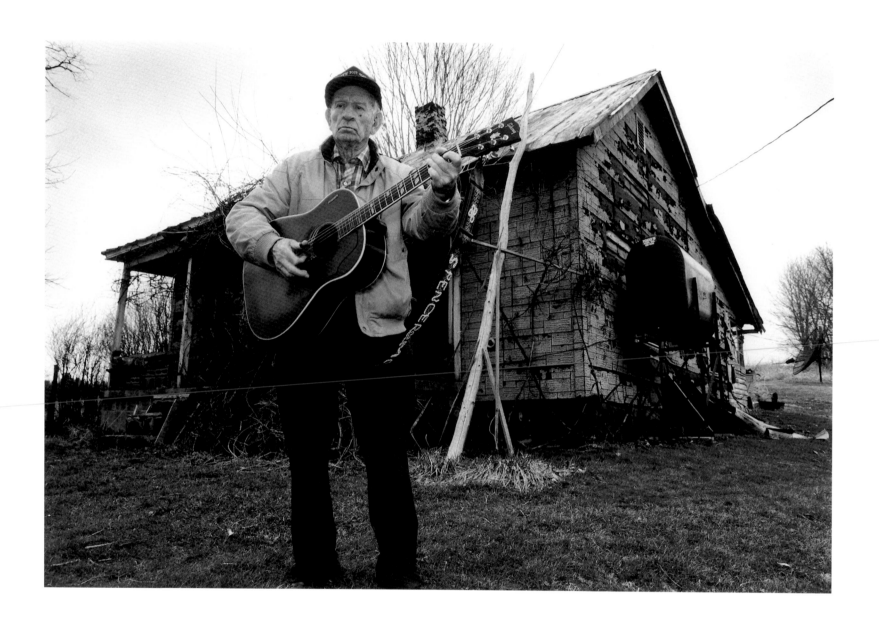

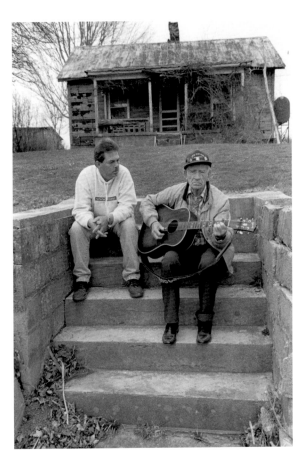

Well, I guess I taught myself how to play guitar. I used to listen to the other musicians in the area, G. B. Grayson, A. P. Carter, you know. Most of them are passed and gone now. But I'll never forget that day when Mr. Lomax pulled up in front of the house. He said he came from Washington, and that he was going to make it so that people could hear my songs forever. I heard that and I said, "Well, I'll be …"

Spencer Moore
Master, Appalachian Song

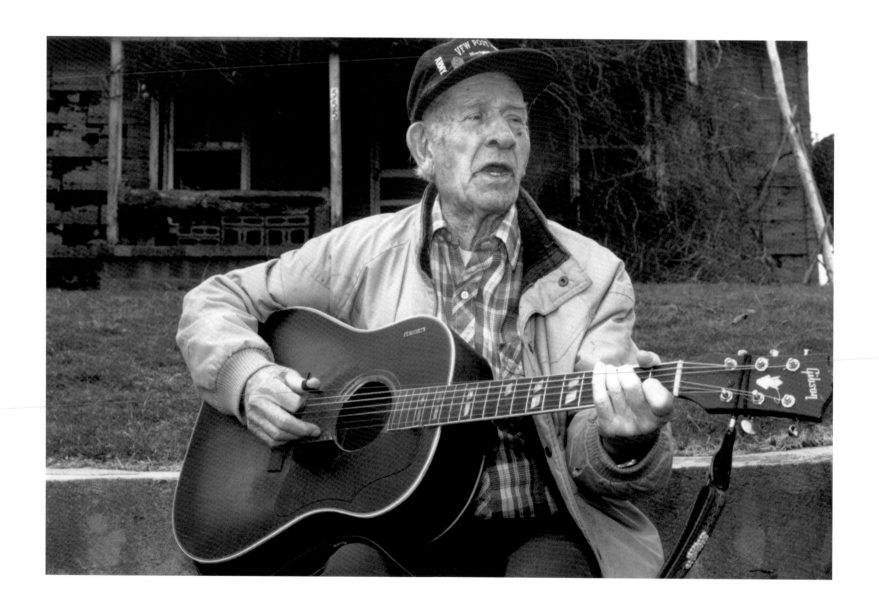

Kathak Dance

Master Artist
Asha Vattikuti

Apprentice
Janhavi Kirtane

KATHAK DANCE IS AN ANCIENT STORY-TELLING dance form, originally performed by bards to narrate the stories of gods and goddesses in the temples of Northern India. Asha Vattikuti has spent a lifetime working and studying the art of Kathak dance, having first learned it from leading Kathak masters as a child in India. She has been teaching Kathak for the past twenty years, first in Detroit, Michigan, and currently in Northern Virginia, and has trained several young dancers to the professional level. Asha has performed, both as a solo dancer and with her troupe, extensively in India, the United States, and Canada. She has also produced and choreographed several dance productions of Kathak with many of the leading dancers of India. Asha's apprentice, Janhavi Kirtane, has been studying dance since her childhood, and hopes to one day teach the Kathak tradition to others.

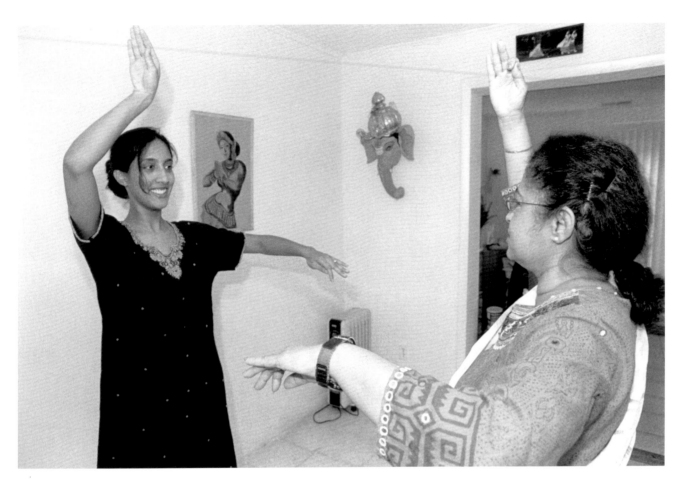

I don't have a set plan or schedule for Janhavi. It's not like "today we do this, next week we do that." We take each step only when she's ready. In Kathak, every movement, in fact every joint and every muscle in your body, is very conscious and deliberate. To be a good dancer it takes a tremendous amount of time and dedication. Will Janhavi have the level of dedication necessary? I don't know. But I can tell you, she has the makings of a very good dancer.

Asha Vattikuti
Master Kathak Dancer

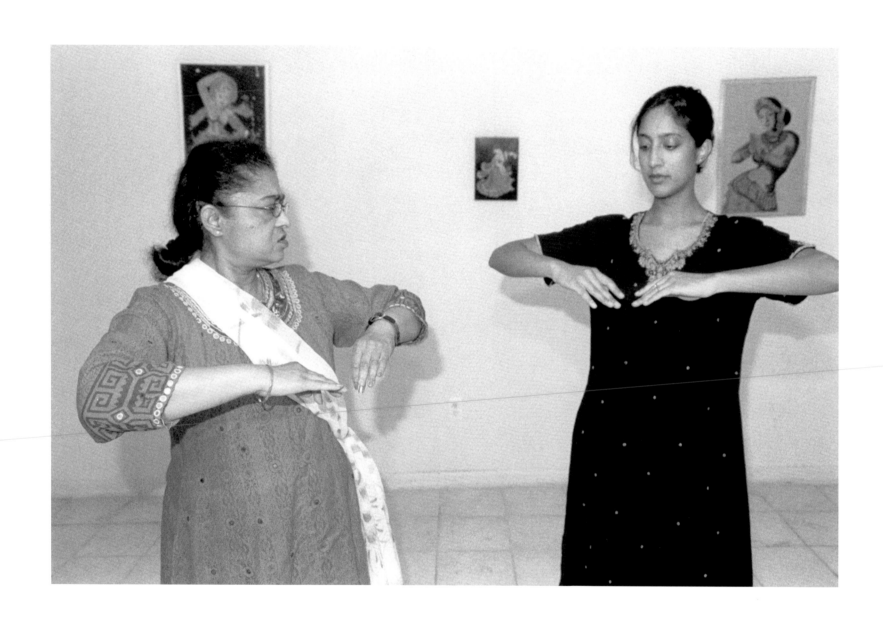

Snake Cane Carving

Master Artist

Norman Amos

Apprentice

John Buck

THE ART OF SNAKE CANE CARVING IS PRACTICED throughout the world, and has a rich history in southern Appalachia. The process begins when a vine wraps itself around a tree branch and fuses to it, ultimately causing the branch to die and fall. The result is a wooden stick with a snake-like coil wrapped around it. In the hands of a skilled carver, this coil is transformed into an arrestingly lifelike serpent. Retired tobacco farmer and mail carrier Norman Amos of Pittsylvania County stands as the greatest living master of this cherished craft. Known for his legendary attention to detail, Norman creates snake canes that often mirror their living counterparts down to the number of scales. Norman recently achieved his lifelong goal of carving one cane for every species of snake indigenous to Virginia. Through the Apprenticeship Program, Norman has taught the art of snake cane carving to his apprentice, renowned gunsmith and woodworker John Buck.

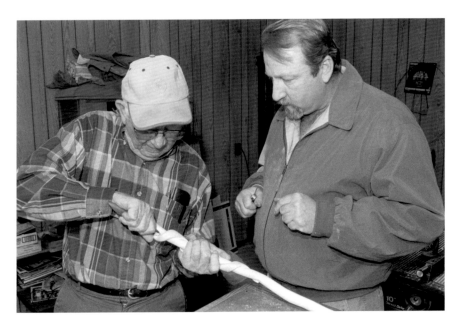

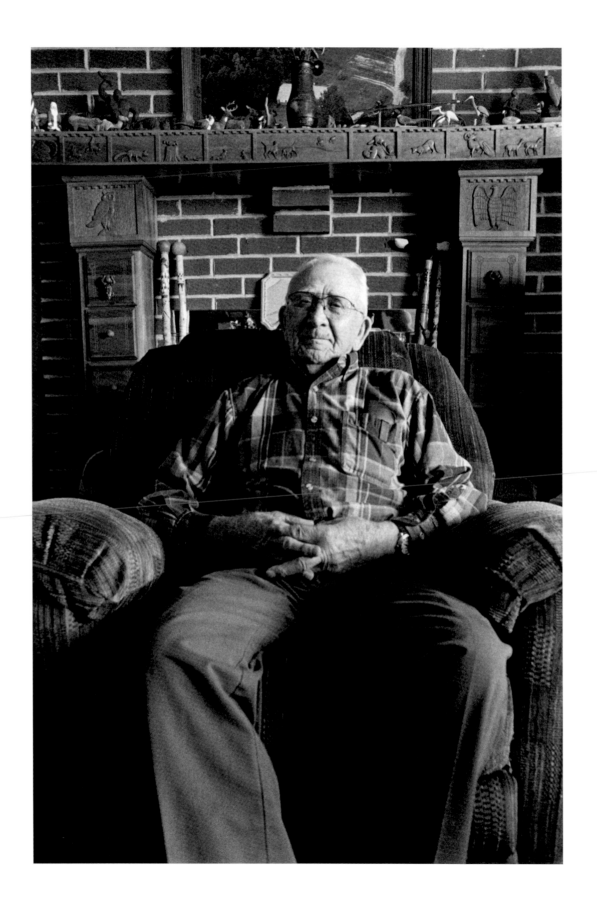

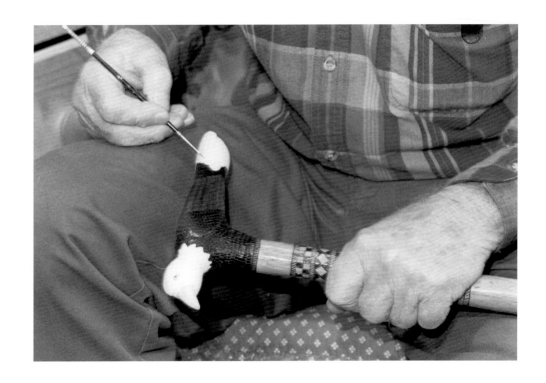

Back when I grew up, didn't hardly anybody have electricity, radio, or television for entertainment. When people got together, the men would go out by the woodpile and sit around chewing tobacco and whittling. So, really it was just something that you did. I've just always carried a pocketknife with me, ever since I was a boy.

Norman Amos
Master Snake Cane Carver

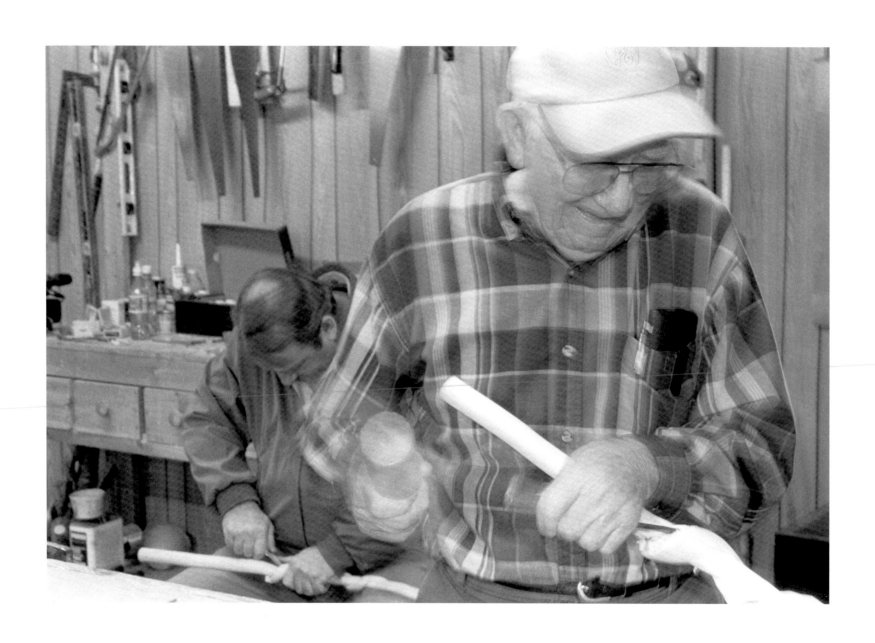

Three-Finger-Style Banjo

Master Artist
Kinney Rorrer

Apprentice
Jeremy Stephens

KINNEY RORRER IS CONSIDERED THE PREMIERE SCHOLAR and performer of the three-finger banjo style first popularized by the great "North Carolina Rambler," Charlie Poole. "Three-finger" banjo playing consists of deftly inserting a series of "rolls" or finger patterns into the playing of old-time music tunes. Kinney is uniquely situated to teach Poole's style—he is a descendent of Poole and the grandson of Poole's legendary fiddler Posey Rorer. Kinney grew up deeply immersed in old-time music, and has become one of its foremost ambassadors. He delights and educates listeners every week with his weekly mountain music radio program *Back to the Blue Ridge*. He is also an avid collector of classic and rare 78-rpm recordings and vintage instruments. Kinney taught his gifted young apprentice, Jeremy Stephens, using the same banjo with which Poole made his final recording, *The Milwaukee Blues*.

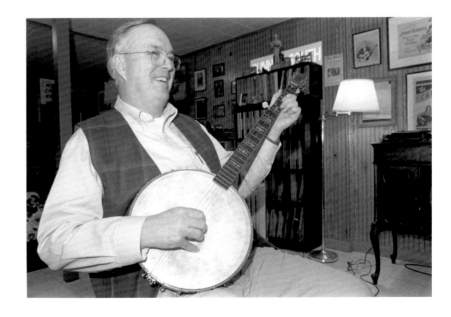

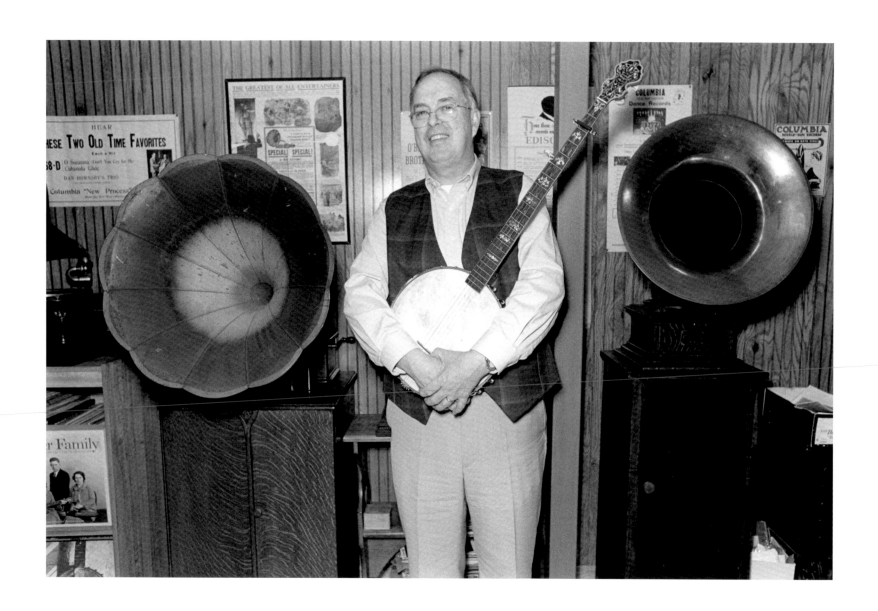

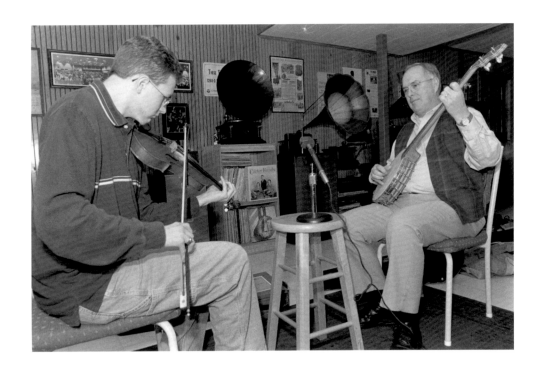

*My mom and dad told me that when I was about eighteen months old
my dad always kept a fiddle on the top shelf of his office closet, and
I knew it was up there ... and I used to beg and beg and beg for him to
bring it down. And when he did, they said I didn't act like an ordinary kid.
They said I would hold it and just kind of look at it, instead of banging
it around or whatnot. They said I was real gentle with it. I guess that was
the first sign of my interest in music.*

Jeremy Stephens
Apprentice, Three-Finger-Style Banjo

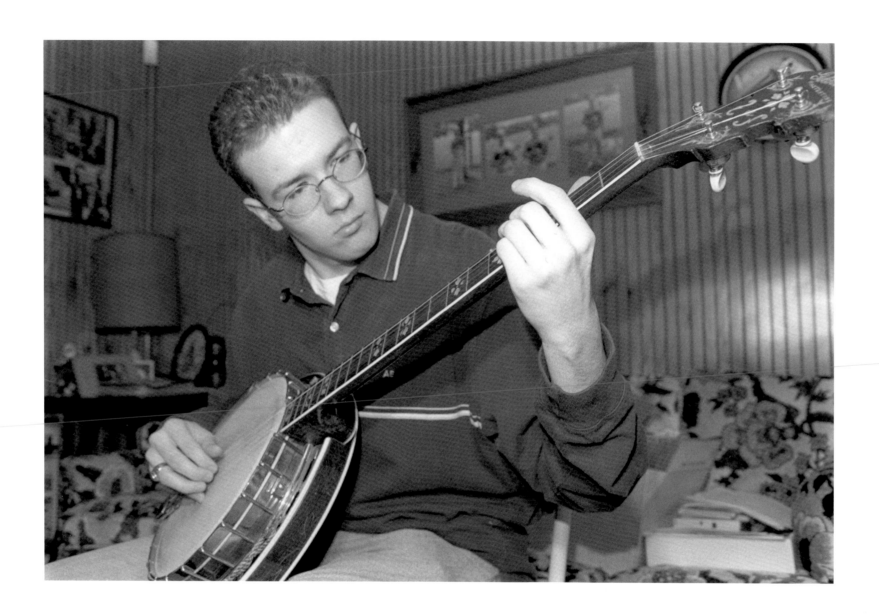

White Oak Basket Making

Master Artist
Clyde Jenkins

Apprentice
Sam Cave

THE TRADITIONAL SKILL OF MAKING BASKETS from white oak is hundreds of years old, involving an in-depth study of the grain structure of the tree. Each white oak tree behaves differently, so basket makers must work with hundreds of trees to gain an intimate understanding of the nuances of the wood. Master artist Clyde Jenkins grew up and still lives on his family homeplace in the Shenandoah Mountains, learning this unique craft from older members of the community. Jenkins is respected as one of the most prolific teachers of this craft, and he relished the opportunity for the one-on-one attention he was able to offer his apprentice, Luray native Sam Cave.

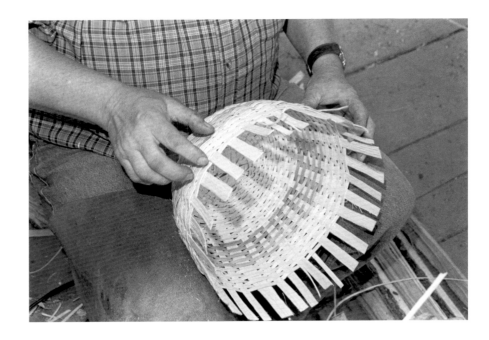

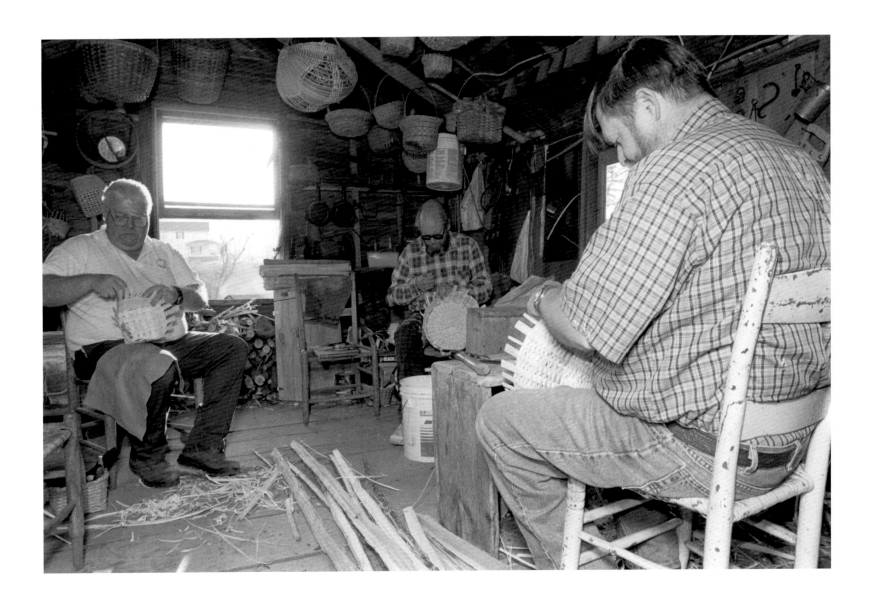

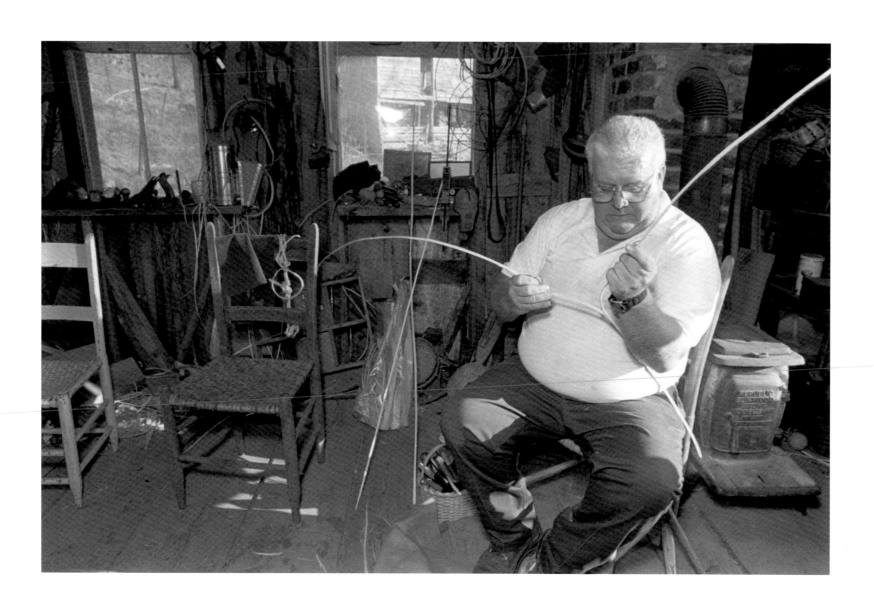

I saw my father and my grandfather work wood as a child, and I wanted to learn how to do it, too. Learning how to do things using these old methods, well, it's really served me my whole life. The way my family lives our life, to be honest, is really not all that different from how my grandfather and his grandfather lived. And it's important for me to pass these traditions along because if I don't do it, who will?

Clyde Jenkins
Master White Oak Basket Maker

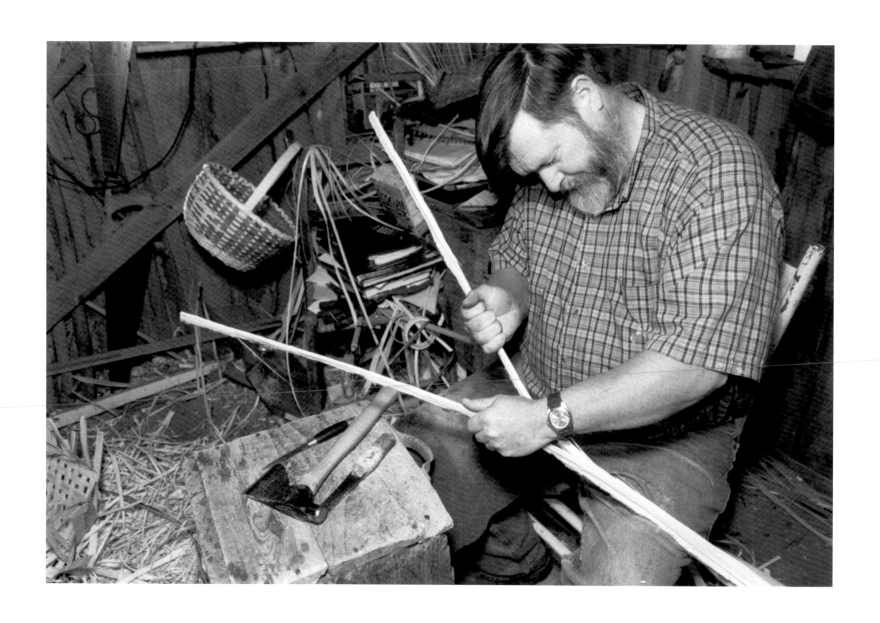

Fiber Arts

Master Artist
Sandra Bennett

Apprentice
Linda Wright

AN APPRECIATION OF APPALACHIAN FIBER ARTS has often been hindered by stereotypical images of Appalachia as a poverty-stricken region, where women had to make every article of clothing and bedding for their family out of necessity, rather than aesthetic expression. Yet, to this day many Appalachian women with great artistic talent spin, knit, and weave by choice and not necessity, making a conscious decision to create beautiful objects and continue the rich handcraft traditions of their foremothers. Sandra Bennett's family has roots in the Appalachian Mountains dating back to the 17th century. Sandra comes from a long family line of strong women who often ran the households, and she is no exception. With the help of her husband, Sandra runs the Thistle Cover Farm, in stunningly beautiful Tazewell County. There they grow their own food and care for their animals, including Romney, Shetland, and other breeds of sheep that have yielded some of the finest fleeces in the Commonwealth. Sandra is an artist as well as shepherd, and she loves sharing her skills with others. She taught her apprentice, Linda Wright, the arts of hand spinning, dyeing, knitting, and weaving.

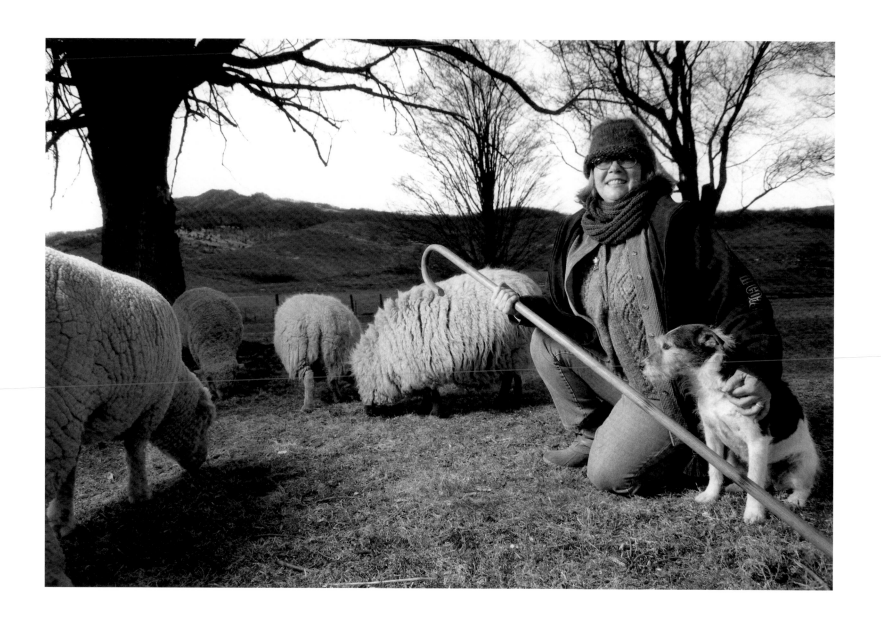

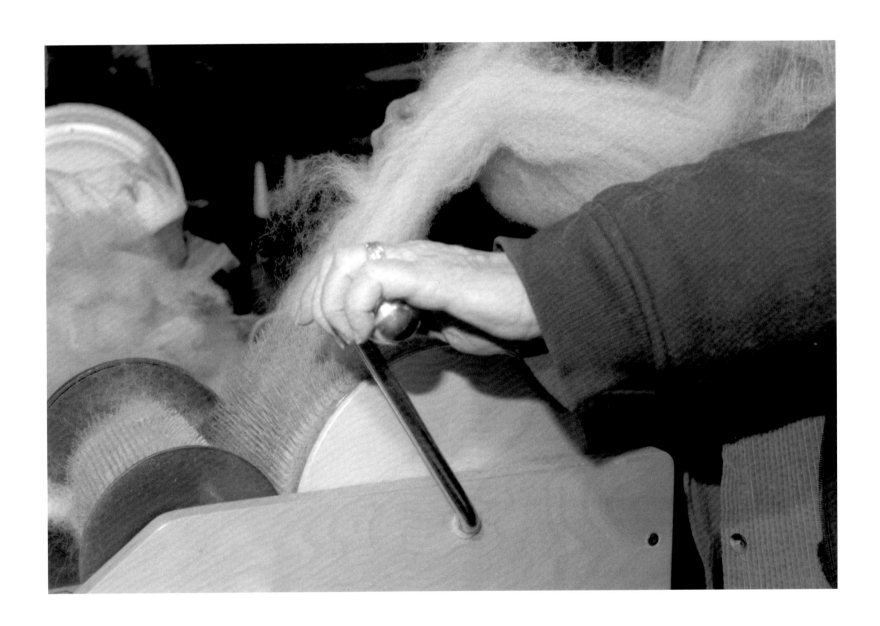

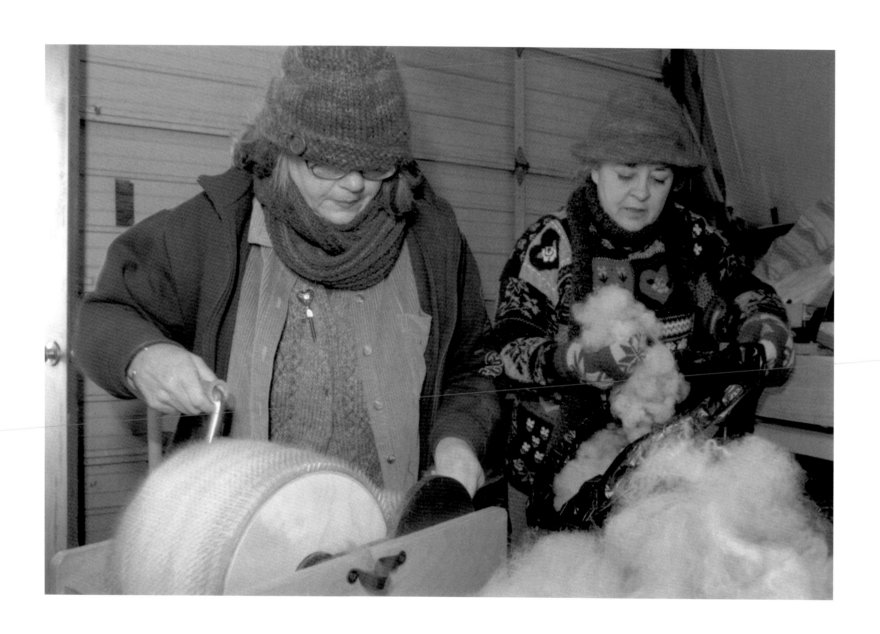

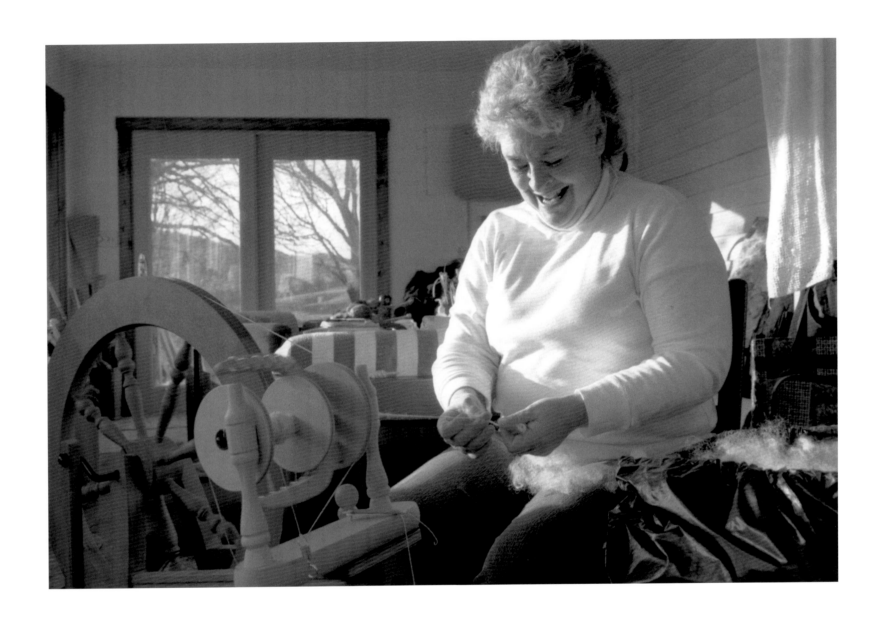

I enjoy teaching and having Linda as an apprentice. Sometimes she would ask, "Now, do you think we should do it such and such a way?" I'm the teacher that goes, "Well, why don't you do it and see?" I think the way I worked with her was to give her permission to fail and succeed. See, if it doesn't turn out right, you need to find another way. For me, every time I do something and I don't get the results I want, I look back and think, "Well, what would one of my grandmothers have done?"

Sandra Bennett
Master Fiber Artist

Flatpick Guitar

Master Artist
Scott Fore

Apprentice
Cheryl Lunsford

THE GUITAR WAS PRIMARILY USED AS A RHYTHM INSTRUMENT in the United States until the late 1930s. As more and more guitar players began to play lead breaks on the guitar throughout the 1940s and '50s, two main styles emerged—"fingerstyle" and "flatpicking." The term "flatpicking" originated with early lead acoustic guitar players in traditional country and bluegrass music who used a plectrum to play the guitar. The plectrum of choice was called a "flat pick" or "straight pick," as opposed to the use of finger picks, thumb picks, or bare fingers to pick the guitar's strings. Scott Fore has established himself as one of the finest flatpickers in the world. Growing up in music-rich Washington County, Scott spent a lot of summer evenings watching the guitar contests at fiddler's conventions throughout Southwest Virginia. Eventually, Scott began competing, and has won countless flatpicking competitions, including the prestigious Winfield Guitar World Championships, the Galax Fiddler's Convention, and the Wayne C. Henderson All-Star Competition. Scott's apprentice, Cheryl Lunsford, has established herself as one of the area's finest female flatpickers.

I'm kind of known around the guitar contests for my stance. Nearly everyone sits but I always stand up with my foot on the chair, and the guitar resting on my knee. It tends to intimidate a lot of guys, and it seems like most of the time the contest is mine before I play a single note. The funny thing is that I came up with this because the first time I competed, my hands were shaking so much I could barely play. So, I actually did it to steady the guitar and keep the judges from seeing how nervous I was! And I guess it's kind of become my trademark.

Scott Fore
"The Flat Pick King"

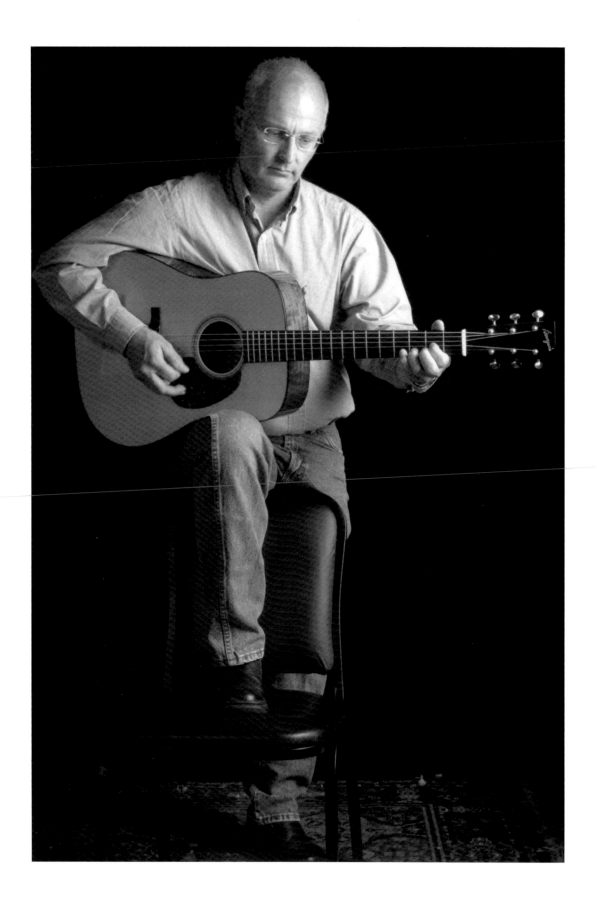

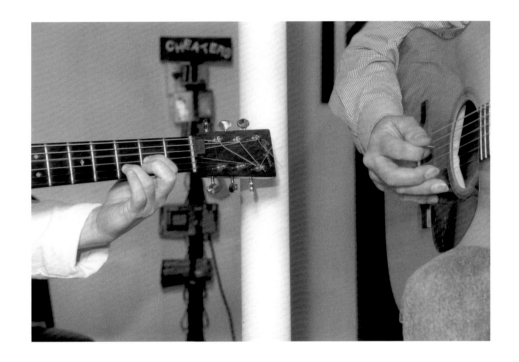

Back when I was a teenager, I used to jam with the musicians out in Floyd. All the guys were saying, "She's getting so good, we're going to have to take her out back and break her fingers." Sure, it was a joke, but they would have never have said that to a boy my age. If I was a boy they would say, "Come on, boy, let's go back and pick some."

Cheryl Lunsford
Apprentice, Flatpick Guitar

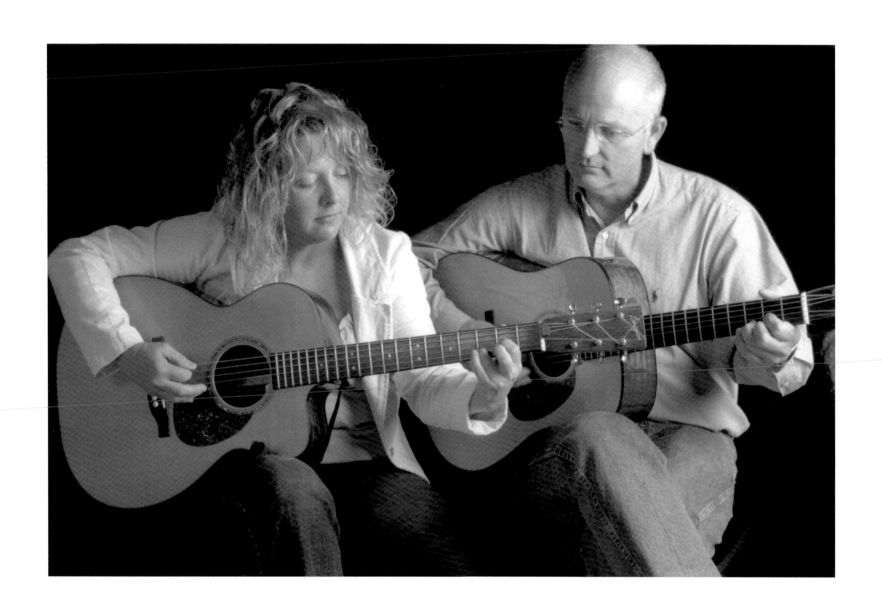

Broom Making

Master Artist
William "Larry" Counts

Apprentices
Thomas Vail
& Dee Puckett

BROOM MAKING HAS ENJOYED A LONG HISTORY in Appalachia and throughout Virginia. Initially, brooms were made primarily as a home craft, and then later became a vibrant cottage industry. Broom makers set up shops in towns throughout Virginia, and it was quite common to see broom corn hanging to dry in homes and shops throughout the region. William "Larry" Counts has been making brooms for more than thirty-five years, and has become a popular fixture at area music and craft festivals. Larry's work is quickly recognizable by the distinctive face he carves into his brooms' handles. Over time, Larry has sought to pay back the older masters who taught him this time-honored craft by teaching his techniques to others. Larry has had several students over the years, but was particularly encouraged by the enthusiasm of two of his apprentices, Thomas Vail and Dee Puckett.

I've been around to a lot of the craft shows, and I've seen his brooms everywhere. And what I love about it is each one is different. It's something made by hand. And besides, he is my uncle, so it's really a legacy thing. It's a way for us to get closer together. He's my father's brother, and my father's deceased. So it's really a way for me to connect with my dad, too.

Dee Puckett
Apprentice, Broom Making

Banjo Making and Fine Instrument Repair

Master Artist
Olen Gardner

Apprentice
Ross Matthews

THE FOLKLIFE APPRENTICESHIP PROGRAM includes various styles of banjo playing, so it was a natural fit to add one in banjo making, along with the invaluable skill of vintage instrument repair. Olen Gardner grew up among a host of instrument makers, and has been developing his craft ever since. Olen constructs bluegrass and old-time banjos, guitars, and the occasional violin. He is a fine banjoist in his own right, having worked with the great Charlie Monroe early in the 1950s. A former toolmaker, Olen has developed numerous tools specifically designed for the construction and repair of stringed instruments. For the past decade, he has served as one of the few authorized repairmen for Martin Guitars, and musicians from all over the world entrust him with their treasured instruments. He has used his apprenticeship to pass his knowledge along to local musician and craftsman Ross Matthews.

You know, when you're fixing something for somebody,
you usually have a bit of leeway when it comes to doing
this or doing that. But when you're working on someone's
instrument, it's a totally different kind of thing. It's like
you got their heart in your hands.

Olen Gardner
Master of Fine Instrument Repair and Construction

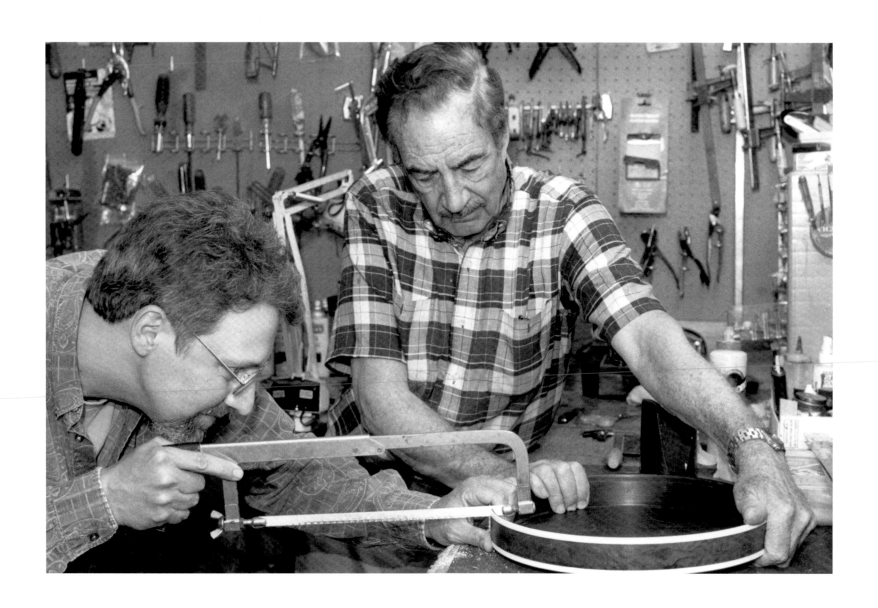

Hewn Log House Construction & Pioneer Crafts

Master Artist
Charles McRaven

Apprentices
Willie Lehmann
& Daniel Malcolm

CHARLES "MAC" McRAVEN HAS BEEN BUILDING with stone, log, and hewn logs since he was 11 years old. His parents built their homes in the 1940s with the help of their children. This fascination has lasted more than fifty years. McRaven has built and restored hundreds of log, stone, and post-and-beam structures all over the United States. His preservation work and writings have earned him recognition as America's leading authority on the preservation of the nation's structural history. Mac's specialty is the preservation of a small but important segment of American history—the hewn or square log house. Mac has passed on his wisdom to two apprentices, Willie Lehmann and Daniel Malcolm.

To see the value of this style, all you have to do is look at modern buildings. They won't be here in three, four hundred years like these old places are now. We're not building like that anymore. We've got a mindset of "Let's keep this place one generation and then throw it away." When we're building like that, we're not honoring our history. By losing the ability to build by hand we're losing the idea of independence that this nation was founded on. These techniques that I'm teaching these guys have been the same forever. I think it's highly necessary to pass them on to younger people

Charles McRaven
Master Log Home Builder

Tobacco Auctioneering

Master Artist
Bob Cage

Apprentice
Jim Crawford

FOR MORE THAN A CENTURY, millions of pounds of some of the highest-grade cigarette tobacco in the world have been grown by farmers in what has been called Virginia's "Old Belt," along the North Carolina border. The Old Belt tobacco was traditionally sold through an auction system that supported not just the local economy, but also a distinctive fabric of local traditions and ways of life. One of the most remarkable traditions to come out of the auction system was the mesmerizing chant of the tobacco auctioneer, and no one has ever done it better than world champion auctioneer, Bob Cage. The key to successful auctioneering, according to Bob, is putting on a show for buyers and spectators, and creating a synergetic rhythm between the auctioneer and the bidders. "The buyers really have to dance to your tune," Bob explains. By the mid-1990s, demand for tobacco in the United States was in steep decline. World markets were changing, and tobacco farming was sustained to a large extent by a system of price supports and allotments that have resulted in the end of the tobacco auction, and with it the hypnotic chant of the auctioneer. Bob is working with documentary filmmaker and tobacco auction enthusiast Jim Crawford, both to record and to pass along this vanishing verbal art.

All right gentlemen, let's go.

(Warehouseman) 155

*One fifty five, 55, 56, give me something, sicky two,
sicky two, Run Johnny!*

170

*Hey I've got him, gone, gone, gone, one seventy, seventy one,
seventy two, hey three, four, seventy five, seventy, Exed!*

172

*Hey seventy two, what'll I do, seventy two, three, four, five,
seventy five, seventy eight, seventy eight dollar, Ginger!*

162

*Hey sixty two, toodee doodly doo-doo-doo, sickity three,
sicky five, sicky five, L and M.*

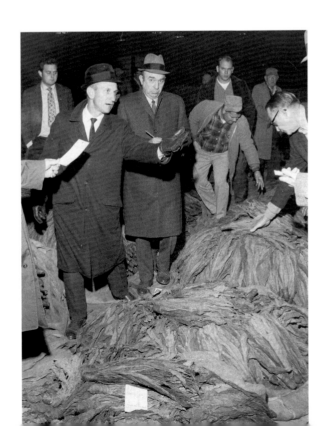

185

Eighty five dollars, eighty five, eighty five, eighty seven,
eighty seven, eighty, ninety dollars, send it to the Queen!

190

Hey ninety dollars, got a ninety one, ninety two-two-two-two-two,
ninety two, and a Run Johnny!

165

Hey sixty sickly five, sickly five, now sickly five, sickly five,
sickly five, seventy, hey, seventy dollars, seventy dollars, Exed.

180

Eighty dollars, eighty dollars, eighty one, eighty two,
eighty three, eighty four, eighty fi, fi, five, eighty five, American.

172

Hey seventy two, toodlely do, give me here, give me five,
give me five, thank you now, seventy dollars and Ginger!

162

Hey sixty two, doodlely doo, what'll I do, sixty five, sell it man,
sixty five, sixty five, L and M.

190

Hey ninety dollar, ninety one, ninety two-two-two-two-two,
ninety two, Run Johnny!

Thank you gentlemen.

Bob Cage chant transcribed by Jim Crawford.

I never knew what I wanted to do with my life, until I saw my first sale.

It was great for me to make a living that way, working short hours. You just go in and sing your song and you're done. There were about one hundred twenty of us auctioneers. It was sort of like show business, and also sort of like a fraternity. And now it's gone, and I could just cry thinking about it. It was the best free market way of selling. And it's been just an absolute tradition, one of the nicest things that's ever happened to the South. The ambiance of the selling, people bringing in the tobacco, bringing their kids with them, bringing their wives, seeing people they don't generally see, is all gone now. I wish it was still going. Whether it ever will again, I don't know.

Bob Cage
World Champion Tobacco Auctioneer

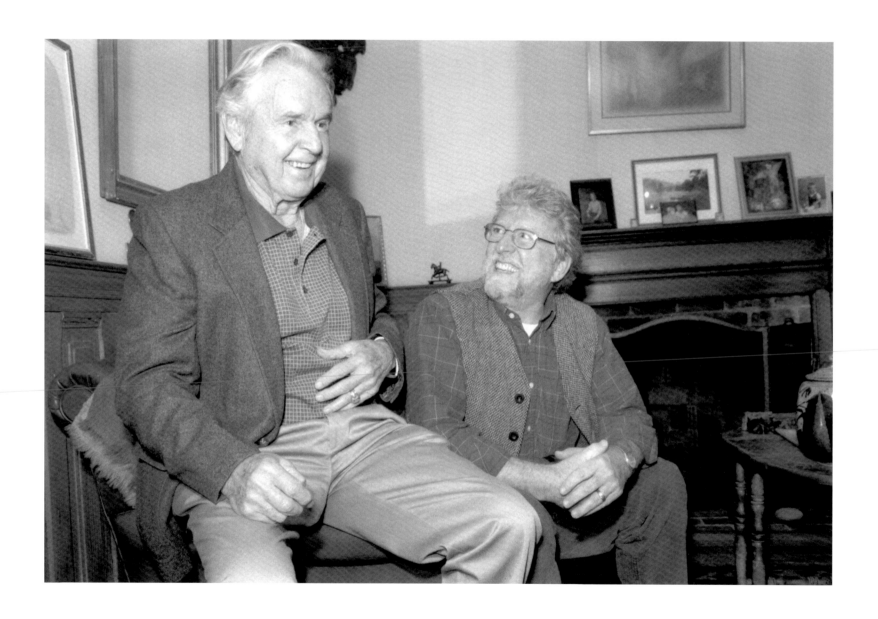

Sephardic Ballad Singing

Master Artist
Flory Jagoda

Apprentice
Susan Gaeta

WHEN THE SEPHARDIC JEWS WERE FORCED INTO EXILE from Spain and Portugal in the 15th century, many settled in other Mediterranean countries but preserved their native language, called Ladino. Flory Jagoda was born in Sarajevo, Bosnia, a member of the famous Altarac singing family of the Sephardic Jewish community. From her *nona* (grandmother), Jagoda learned songs that had been passed down in her family for generations. Jagoda escaped the destruction of Sarajevo's Jewish community and came to the United States after World War II, eventually settling in Northern Virginia. She has been recognized as "the keeper of the flame" of this unique musical heritage and also as a brilliant composer and arranger of new Sephardic songs. Flory is truly a national treasure, and in 2002 she received the National Heritage Fellowship, the highest honor the United States bestows upon a traditional artist. Flory is now her family's *nona*, and in addition to passing her music on to her children, she has taught many other students who now perform Ladino music, including her apprentice, Susan Gaeta. Much like the other apprentices, Susan is an accomplished artist in her own right and demonstrates a deep intellectual and personal interest in carrying on this precious traditional language and music.

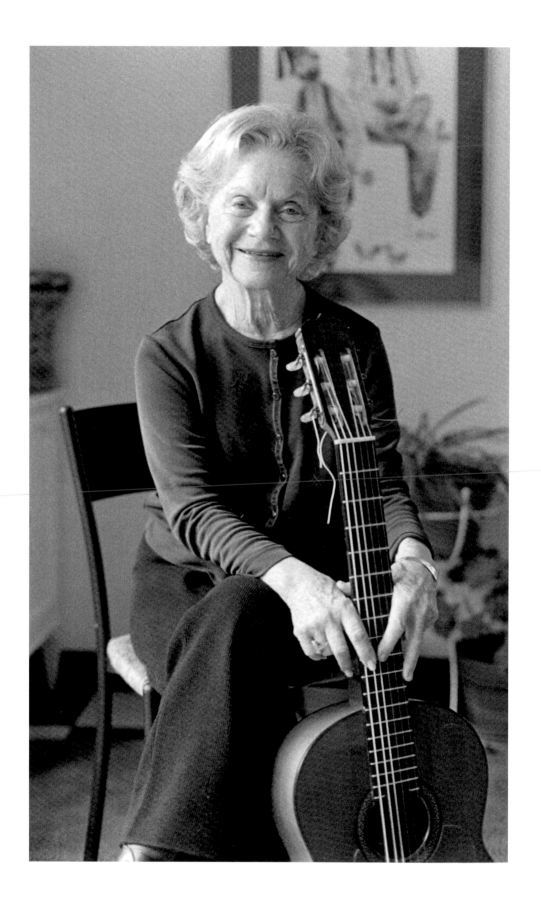

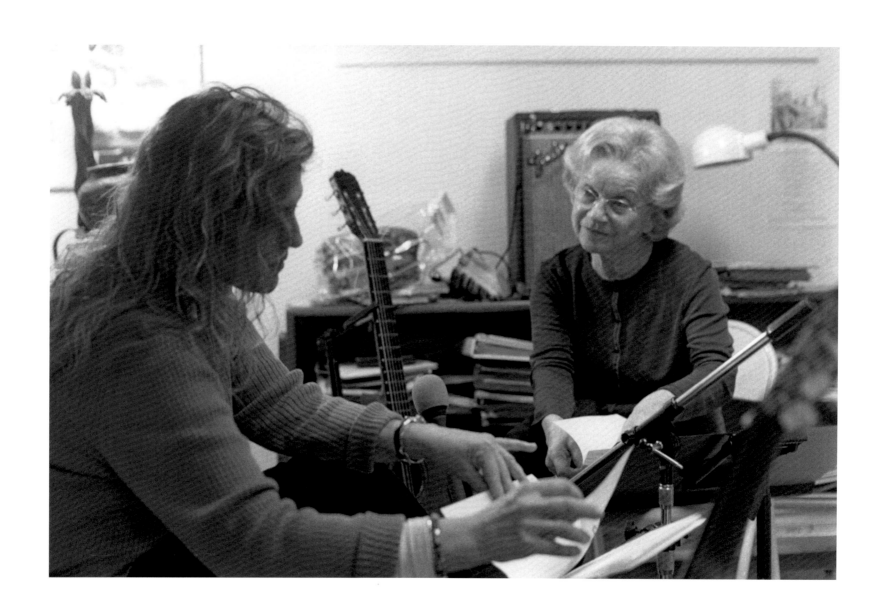

206

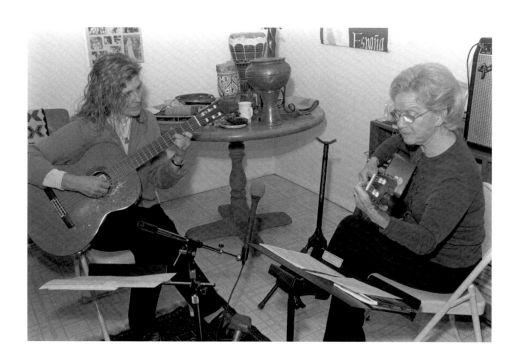

*I arrived in America as a war bride in 1946 with a suitcase full
of memories, both good memories as well as some very ugly ones.
So many of us who survived the Holocaust had one thing in common
—our silence. However, as we grew older, we began to feel the
need to share our pain and also our many happy memories with
the world. I poured my memories into songs. This is where my
whole family has gone—into my songs. I loved Sarajevo and especially
the music; so instead of going back there, I write songs about it.
My family were all incredibly musical and they all loved to sing,
so my best thing to do is make sure that this music continues.*

Flory Jagoda
"The Keeper of the Flame"

Bluegrass Fiddle

Master Artist
Buddy Pendleton

Apprentice
Montana Young

BUDDY PENDLETON OF PATRICK COUNTY HAS LIVED a life in bluegrass music. Buddy is one of the most beloved fiddlers in Southwest Virginia, and a common fixture on the leader board at Galax and other regional fiddling contests. Buddy has won the prestigious first-place fiddle prize at the Union Grove Fiddlers Convention—commonly considered the "world championship" of fiddling—an unprecedented five times. For a while it seemed that Buddy might make a career as a professional bluegrass musician, especially after he got his break touring with the legendary Bill Monroe and his Bluegrass Boys. The road didn't suit Buddy, however, so he decided to give it up to spend more time with his family in the tiny town of Woolwine, where he took up a job as a rural mail carrier. Years later, Buddy still carries the mail and still delivers with his fiddle bow. Buddy's apprentice, child fiddle prodigy Montana Young of Bassett, Virginia, had already won numerous fiddling contests throughout the region before her eleventh birthday.

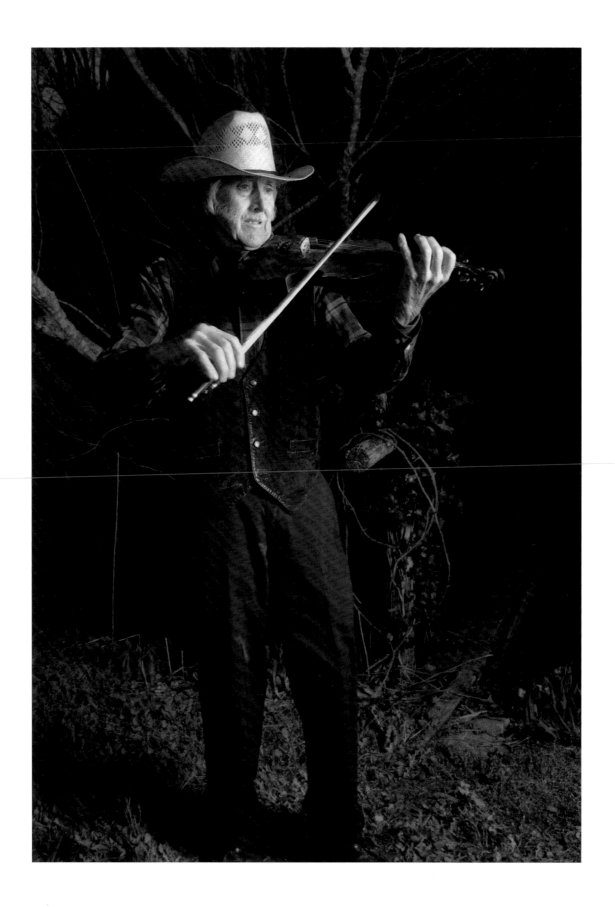

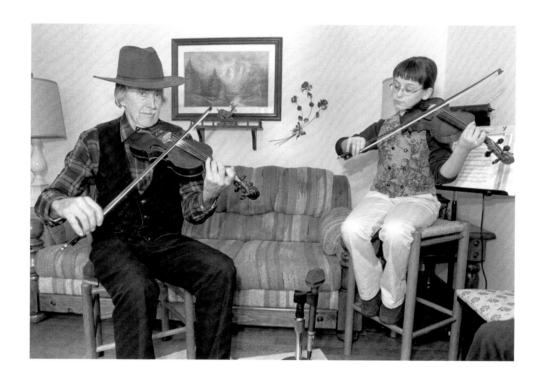

*I've had some experiences in music, and I'll tell you, I just don't think
you're going to find a fiddler any better than Montana at her age.
And obviously, there's more than a few fiddling convention judges out
there who agree with me. I certainly haven't ever bumped into anyone
that picks things up so quickly. I'll play one of these songs one time
through, and then we'll work on it in segments. Nearly every time, she'll
have it down in one session. I just feel lucky to have gotten to teach
her something, because she's truly going to be … well, she already is
one of the true special ones in this music.*

Buddy Pendleton
Master Bluegrass Fiddler

Decoy Carving

Master Artist
Grayson Chesser

Apprentice
Robie Marsh, Jr.

THE EASTERN SHORE OF VIRGINIA, a narrow peninsula stretching roughly seventy-five miles between the Atlantic Ocean and the Chesapeake Bay, has long been a veritable hotbed of decoy-carving masters. The area around Chincoteague Island has been particularly fertile ground for decoy carving over the years, home to the legendary carver Ira Hudson, as well as Dave "Umbrella" Watson, "Cigar" Daisy, Delbert Hudson, and Miles Hancock. Grayson Chesser can trace his family's roots on Virginia's Eastern Shore back to the mid-1600s. As a young man, Grayson Chesser learned at the feet of Hancock and other Chincoteague masters, at a time when the wooden duck decoy tradition was being threatened by the development of plastic hunting decoys. The home-made wooden decoy, traditionally the self-taught craft of the waterman for the specific purpose of hunting, has since become a coveted object among art collectors, and Grayson's decoys are always in high demand. And while many of his decoys end up directly on the collector's shelf, Grayson, himself an avid hunter, still carves each to be a working, hunting decoy. Grayson and his apprentice, Eastern Shore native Robie Marsh, Jr., shared carving secrets and hunting tales in the woodshop and house where his mother and her father and grandfather grew up, in the tiny town of Jenkins Bridge along Holden Creek.

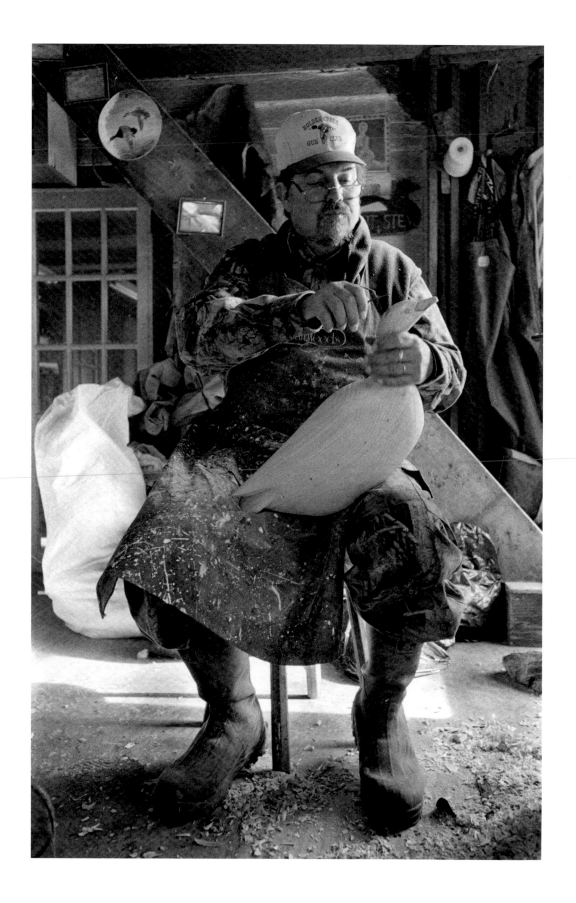

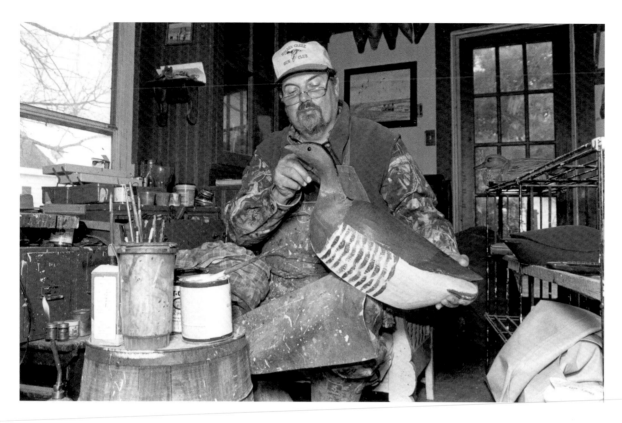

The old carvers who taught me, guys like Miles Hancock, they're all passed and gone. There's nothing I can really do to thank them now. So I always thought that if maybe there's somebody else I can help, then that could sort of be my way of repaying them. So, this work I'm doing with Robie is really a continuation of what those guys have done for me.

Grayson Chesser
Master Decoy Carver

Brunswick Stew Making

Master Artists

John D. Clary

Phil Batchelor

Lonnie Moore

Apprentice

Chiles Cridlin

WHAT BEGAN, ACCORDING TO AREA LEGEND, AS A COMMUNAL MEAL prepared for a hunting expedition on the banks of the Nottoway River in 1828, the cooking of Brunswick stew has evolved into a time-honored tradition— a staple at community gatherings, a source of regional pride, the focus of spirited competition, and a true Virginia culinary art. In Brunswick County, the eight-hour process of cooking a hundred or so gallons of stew is performed in fire houses and other community gathering places by groups of men, or "Crews." Each crew is led by a "Stewmaster," a title that takes years to attain. John D. Clary first helped cook Brunswick stew under the watchful eye of Stewmaster McGuire Thomas when he joined the Lawrenceville Volunteer Fire Department in the fall of 1973, eventually ascending to the level of Stewmaster in 1988. John has been an avid participant in the "Stew Wars" with Brunswick, Georgia, which also asserts a claim to the stew's origin. John joined with fellow Stewmasters Phil Batchelor and Lonnie Moore to tutor closely their apprentice, Chiles Cridlin. Chiles is now a proud member of John Clary's Proclamation Stew Crew that will cook any size stew, anywhere, for anyone, as long as it doesn't interfere with a Virginia Tech football game.

Proclamation Stew Crew's Recipe

(minus a few secret ingredients)

In a 150-gallon pot add: makes 600 servings

320 chickens (deboned)

24 additional chicken breasts

250 potatoes

150 onions

24 gallon cans of tomatoes

34 gallon cans of butter beans

24 gallon cans of white shoe peg corn

15 boxes of margarine

2 boxes (1 box = 26 oz.) salt

10 boxes sugar

12 oz. black pepper

12 oz. red pepper

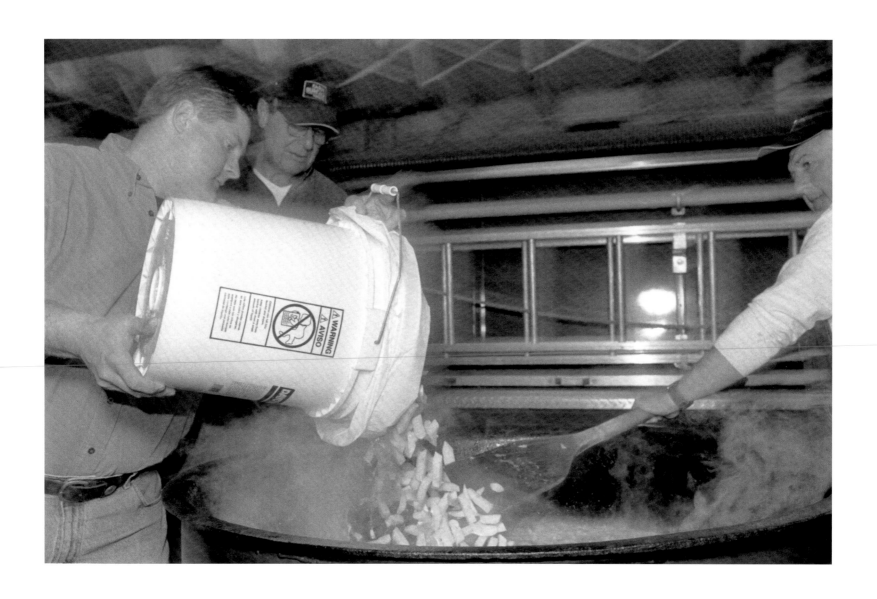

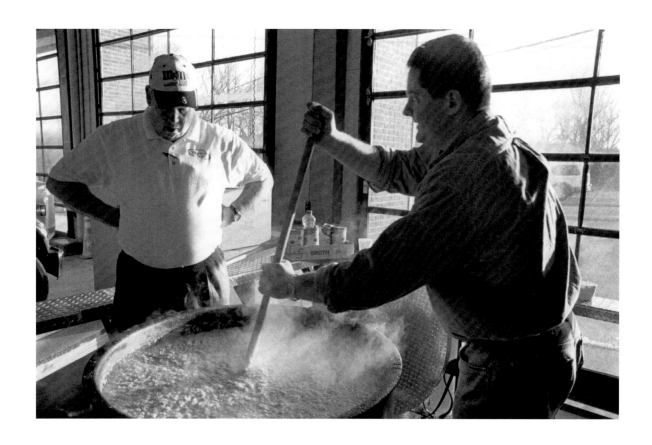

Since getting hooked up with us, Chiles has been in on nearly every stew we've done. And I think he's taken a little something from all of us. Lonnie took him under his wing on some things, then he'd spend time with Phil, then me. Because each Stewmaster is going to do it a little different. I can close my eyes, taste a stew, and probably tell you who made it. But on this last stew, we just sat back, and let him run the show. We just helped him stir, peel, whatever. Well, okay, maybe we'd let him know when he's late on this, or if it could use a little more of that. That's going to happen, you know. But I'll tell you, I think he's ready to fly on his own.

John D. Clary
Brunswick Stewmaster

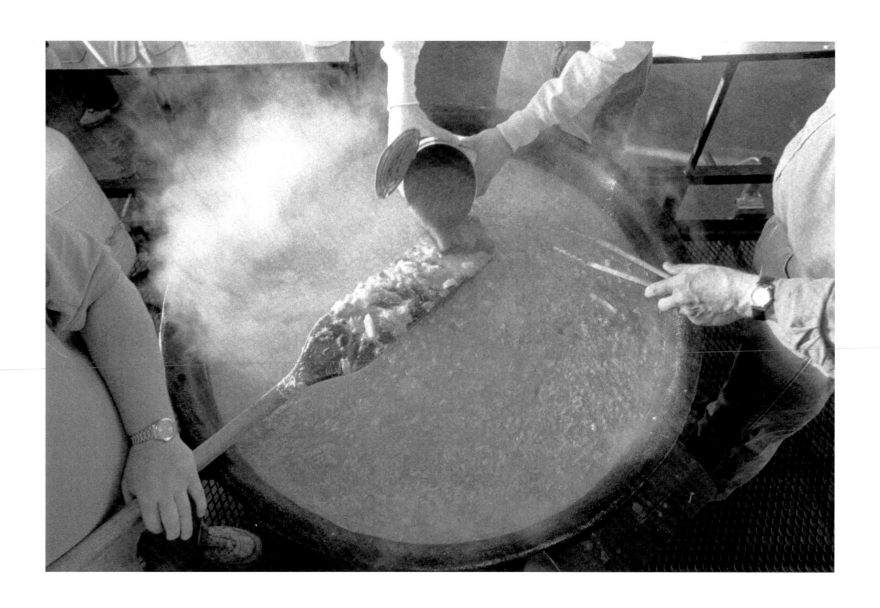

INDEX OF MASTERS

ABOUT THE VIRGINIA FOLKLIFE PROGRAM

The Virginia Folklife Apprenticeship Program pairs experienced master artists from a wide range of traditional art forms and skills with apprentices for a nine-month, one-on-one learning experience. Apprenticeships are open to applicants in all forms of Virginia's traditional, expressive culture.

The Virginia Folklife Apprenticeship Program is one of the hallmark initiatives of the Virginia Folklife Program, which, since its inception in 1988, has worked to document, present, and support the state's living cultural folkways. In addition to awarding Apprenticeships, the Folklife Program produces educational materials and programs for the general public, including lectures, workshops, music and video recordings, performances, and exhibitions. The Folklife Program conducts ethnographic fieldwork throughout the Commonwealth, capturing the stories of everyday people living extraordinary lives, and documenting many ways of life that are unique to the region, and may be on the cusp of great change. The field material collected by the Folklife Program results in the production of sound and video recordings, as well as a growing fieldwork archive. The Virginia Folklife Program collaborates with countless cultural institutions and serves as a general resource and advocate for traditional artists throughout the Commonwealth.

The Virginia Folklife Program is a public initiative of the Virginia Foundation for the Humanities (VFH), created in 1974 to develop the civic, cultural, and intellectual life of the Commonwealth. From its inception, the VFH has remained steadfastly dedicated to bringing the humanities fully into Virginia's public life, assisting individuals and communities in their efforts to understand the past, confront issues in the present, and shape a desirable future.

For more information about the Apprenticeships,
the Virginia Folklife Program, and the VFH please contact:

Virginia Foundation for the Humanities
145 Ednam Drive
Charlottesville, Virginia 22903
(434) 924-3296

 WWW.VIRGINIAFOUNDATION.ORG

 WWW.VIRGINIAFOLKLIFE.ORG

ACKNOWLEDGMENTS

THERE ARE MANY PEOPLE TO THANK for the creation of the Virginia Folklife Apprenticeship Program, and for making this book possible. We'd first like to express our deep gratitude to the National Endowment for the Arts and in particular Folk and Traditional Arts Director Barry Bergey for their continued, generous support of the Folklife Apprenticeships. Additional support for the Folklife Apprenticeships came from the J&E Berkley Foundation. We owe a debt of gratitude to Robert Vaughan, president of the Virginia Foundation for the Humanities, for his unwavering support and enthusiasm for the work of the Virginia Folklife Program. Rob has been a stalwart advocate for the Folklife Program since day one, and he has given the program wings. We'd also like to thank the entire staff of VFH, and in particular Tori Talbot, who has coordinated the program and organized the annual Virginia Folklife Apprenticeship Showcase. The Folklife Apprenticeship Program has benefited from the advice and recommendations of numerous people throughout Virginia, and we'd like to particularly thank Roddy Moore, director of the Blue Ridge Institute at Ferrum College, for bringing so many fine artists and folk traditions to our attention.

We owe a special debt of gratitude to Laura Chessin, our graphic designer and general taskmaster, for lending her immeasurable talents to this project. Emily Salmon, Jeanne Siler, and Jeff Rothstein provided invaluable editing suggestions. This book could not have come to be without the support and guidance of David Bearinger, a great colleague and collaborator. And finally, we want to thank all the participants in our Apprenticeship Program, masters and apprentices alike, for their dedication, generosity, and artistry. Getting to know each and every one of you has been nothing short of a blessing to our lives.

PRODUCTION NOTES

All photographs for this book were taken using "traditional methods"—
film, chemicals, and photographic paper. Morgan shoots with Nikon F3
35mm camera backs and Nikon lenses with Kodak T-max 100, 400, and 3,200
ASA speed films. The prints were made with a forty-year-old Omega enlarger,
on Agfa Multi-contrast fiber-base paper for the portraits, and Ilford RC paper
for the other images.

The type used for this book is a digital version of Electra designed by
W. A. Dwiggens, (1880-1956) an American typographer considered a master
of lettering, type design, and book design, early in the 20th century.